9/8

Special Optical Effects

FOCAL PRESS LTD.,
31 Fitzroy Square, London. W1P 6BH

FOCAL PRESS INC.,
10 East 40th Street, New York, NY 10016

Associated companies:
Pitman Publishing Pty Ltd., Melbourne.
Pitman Publishing New Zealand Ltd., Wellington.

Special Optical Effects

in Film

Zoran Perisic

Focal Press Limited, London

Focal Press Inc, New York

First Edition 1980

British Library Cataloguing in Publication Data

Perisic, Zoran
 Special optical effects.
 1. Cinematography – Special effects
 I. Title
 778′5′34 TR858

American Library of Congress Catalogue No: 80–41005

ISBN 0 240 51007 0

Phototypeset by Computer Photoset Ltd, Birmingham
Printed and bound in Great Britain
at The Pitman Press, Bath

Contents

Aerial image and toplights; Bipack operation; Aerial image zoom; Zoptic screen; The Zoptic effect; The slit-scan.

Back projection; Motor drives; The lamphouse; Projection lenses; The screen; The hot spot; The line up; Using back projection; Back projection and matte paintings; Front-axial projection; Front projection screen; The projector; Projector movements; Beamsplitter; Fringing; Fringing and the zoom lens; Fringing and focus; Lining up procedure; Camera mount; The nodal head; Lighting for front projection; Skylight; Polarised lighting; Matching the colour; Blending in the foreground; Front projection plates; Grading; Exposure; Setting up a front projection shot; Shooting off the mirror; Going 'behind' foreground objects; Masking off; Front projection and matte paintings; Ghosting; Flames; Front projection and miniatures; Dual screen system; Suspension methods: wires; Painting out wires; Suspension methods: the pole; Lightweight projectors; Moving the front projection assembly; Rotation; Double pan and tilt heads; Movement in depth; Zoptic front projection; The flying rig; Zoptic without zooms; Shot planning; Using the Zoptic; Front and back projection Zoptic screen; Mixing formats; Front projection screen construction; Covering large areas; Soft backing; Hard backing; Patching up; Curved screens.

1 In-camera effects

A great deal of optical effects work can be accomplished with conventional cameras and equipment. In fact there is no clearly defined borderline dividing conventional cinematography and special optical effects.

Although most of the 'in-camera' effects can be achieved by other means, these other methods require the original negative to be duplicated whilst in-camera effects are always first generation. This is a very important consideration, even when the same scene may have to be duplicated later on, in order to add some other optical effect which cannot be done in the camera; at least one generation of duplication can be avoided.

Reverse action

You can make a person appear to jump out of the water and land on a diving board simply by running the film backwards through the camera during the shooting. Most cameras are capable of shooting in reverse, and those which do not have this facility can often be easily adapted. The camera mechanism itself is just as capable of running backwards as forwards but you have to ensure that the film is being taken up properly when running in reverse. DC motors can be made to run backwards by simply changing over the positive and negative contacts. Synchronous three-phase motors can be made to run in reverse by changing over any two of the three contacts on the power supply, avoiding at all costs the fourth contact which is neutral.

When all else fails the backwards effect can be accomplished by

turning the camera upside down and shooting forwards, as normal. The film is turned the right way up for projection. There are two main disadvantages with this method which you should be aware of. Firstly, the registration pins engage the film perforations at the top of the frame instead of the bottom (or vice versa) because the picture within the frame area is upside-down. This only presents a problem if the same scene is to be duplicated so that other opticals can be added to it, as it could make the image unsteady. The simple remedy for this is to ensure that the same perforations are used during the next stages in the preparation of the opticals.

The second disadvantage of shooting with the camera upside-down is that the sound track position is reversed. Of course this problem does not arise in 16mm shooting but make sure that the negative you use is perforated on both sides (double perforation) otherwise it is not possible to cut the negative of this scene into the rest of the film. In 35mm shooting you must ensure that the Academy mask is removed from the gate so that you can utilise the full picture area. When framing, remember that your effective Academy area is now shifted to the opposite side of the full aperture reticle. In some cases it is possible to turn the ground glass in the viewfinder around so that the Academy area is indicated correctly. Alternatively a ground glass can be prepared specially for this purpose.

Reverse action can be used very effectively for dramatic as well as the obvious comedy effects. It is enhanced when other action within the frame area appears perfectly normal; in reality people have to walk backwards and perform all other actions in reverse during the shooting. There is a scene in Jean Cocteau's *Beauty and the Beast* where the camera pans along with the character and, as he walks towards a fire, his hand reaches into the flames and pulls out a piece of paper which appears to materialise out of the flames. Another use is to bring a crushed flower to life again; each petal is revived individually and joined onto the stem.

Stop motion

Virtually all professional cameras have accessories to facilitate single-frame shooting. In most cases this means the substitution of the standard 'live' motor for a stop-frame one. In addition to this it is also possible to have an automatic time lapse device (an intervalometer) which activates the stop-motion motor at preset regular intervals. This is particularly useful when shooting a plant flowering and similar situations where the desired change takes a very long period of time. The main consideration in the fitting of

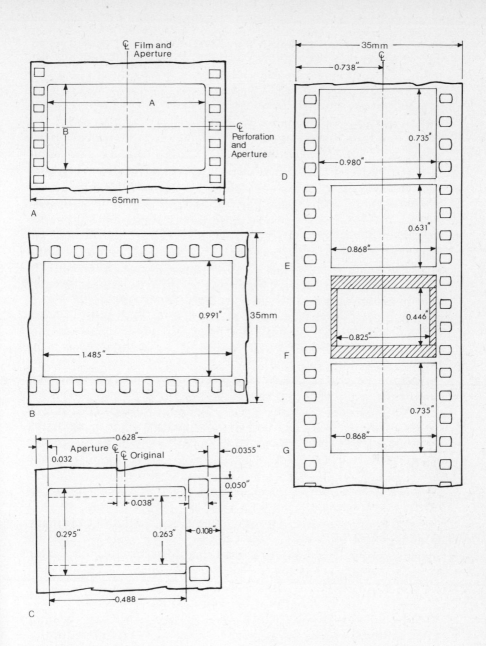

A 65 mm.
B Vistavision or double format.
C Super 16 mm.
D 35 mm full aperture (silent).
E Academy aperture (1.33:1).
F Wide screen (1.85:1).
G Wide screen anamorphic (2.35:1).

11

the stop-motion motor is that the camera shutter is in the closed position when the motor stops; this should be the case when the motor is running either forwards or in reverse. The other important consideration is the exact exposure time the particular motor gives in use.

Stop motion can be used to provide some really zany backgrounds to equally zany foreground actions that can be added optically later. Combined with a judicious use of reverse action, it can also be very amusing in itself. Stop motion is particularly effective when only inanimate objects are being photographed, a wall being built for example. As each brick is laid in position a single frame is taken (or two or more frames if the action needs to be slowed down). At a predetermined point the film can be advanced by, say, 100 frames and the same stage in the building of the wall is recorded at this point. As each brick is laid from then on it is photographed on successive frames and also on frames before and after the 100 frame point. This frame acts as the key point, representing the 'low' when the film is run normally. After this point the wall appears to carry on building. The result is that on projection the wall appears to build itself, 'hesitates' at one point, goes back and then continues to build.

A simple version of stop motion is to photograph an action from a chosen zero point both forwards and in reverse. In this way you obtain a record of the same action in both reverse and forward modes. The two sections are then fully interchangeable. For example, a cloth can be torn and mended by either visible or invisible means; objects can be twisted or bent out of recognition and then spring back to their normal shapes, etc. In this case the sequence is: expose; wind forward 199 frames; expose; wind back 198 frames; expose; wind forward 197 frames; expose, etc.

Faded frescos on partially ruined walls can appear to brighten up as they are restored to their former glory, finally mixing to a matching live action composite. The frescos are painted over with chemicals which gradually bleach or destroy the painted image and the entire procedure is shot stop-frame and in reverse action. (Naturally this would not be done with real frescos.) If the people in the fresco are to be brought to life then it is best to shoot the live action scene normally, starting with a 'freeze'. A frame from the front of the chosen take is used for rotoscoping (projecting through the camera) so that the exact outlines of the characters can then be traced by an artist. When the fresco is painted and photographed in reverse as it 'ages' there will be no problem in matching the images. The two sections are joined by a *dissolve* in the printing stage (*see* A and B roll printing).

12

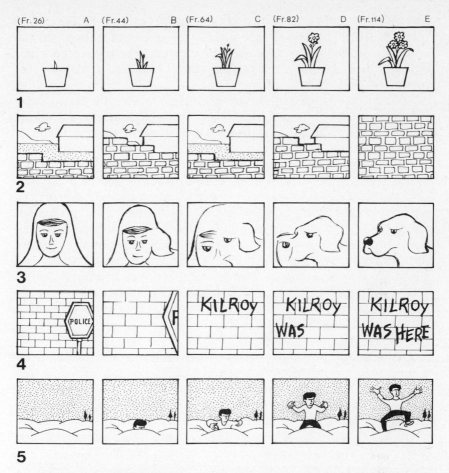

1 A plant grows visibly. **2** A brick wall builds itself, then goes down again before it continues to build up once more. **3** Rubbing out certain parts of the picture as others are added on can produce subtle transformations. **4** A zoom in to a brick wall before or after live action can be used to animate hand-drawn titles, by changing over to stop motion shooting with the appropriate compensation for the exposure difference. **5** A live action figure can appear to shoot out from a hole in the ground.

Stop motion and live characters

Although stop motion is normally used to photograph inanimate objects, it is quite possible to use it for shooting live characters. Characters can be treated in the same way as puppets except that they can make their own move in between frames. People can appear to slide along as if propelled by some unseen force, sometimes leaving a furrow in sand as they move. A figure can be made to slither along the floor in a snake-like motion or appear to squeeze in or out of caves, rock crevices, holes in tree trunks, etc,

13

and all as though driven by some supernatural power! Fast, zany movements of this kind are not difficult to accomplish by simply running the camera at a slow speed (undercranking) and shooting continuously. However, really smooth stunning effects require frame-by-frame control and an understanding of the animation principles on the part of both the operator and the performer; inevitably, it takes time. Naturally, there should be no other 'normal' movement in the background for this type of shot.

Undercranking and overcranking

Undercranking means that the camera motor is turning at less than 24 fps; this results in the speeding up of the action when it is projected at normal speed. Standard motors are normally of the *variable speed* type, which can run at a few frames a second or two or three times the normal speed. For speeds above this range special high speed motors can be used, although maximum speeds are achieved by specially designed high-speed cameras.

Variation of the camera speed varies the exposure time; this is normally compensated for by either adjusting the lens iris setting (f stop), closing down the shutter where a variable shutter is fitted, or by the use of *neutral density* filters. Every time the camera speed is doubled, the exposure time is effectively cut by half and this would result in one f stop underexposure unless the lens iris is opened up by one f stop to compensate. When the camera speed is reduced, the effective exposure time is increased proportionally. At 12 fps this would give an overexposure of one f stop if not compensated for; at 6 fps the difference is 2 f stops.

At slower camera speeds the exposure time can be reduced by closing down the variable shutter. If the normal shutter opening is 180° at 24 fps then, at half that speed (12 fps), the shutter should be set at 90° to maintain the same effective exposure time and the iris setting (f stop) need not be altered. At 6 fps the shutter is closed down to 45° and at 3 fps the shutter is set at $22\frac{1}{2}°$. The effective exposure time remains at the same value as it would be at 24 fps, that is 1/50 sec.

Varying the motor speed during a take

When a scene is required to start with the camera running at normal speed and then undercranked so that a specific action appears to accelerate, the exposure must be maintained throughout the change in the camera speed. This can be done by manipulation of either the camera shutter or the lens iris. In either case the manipulation must

14

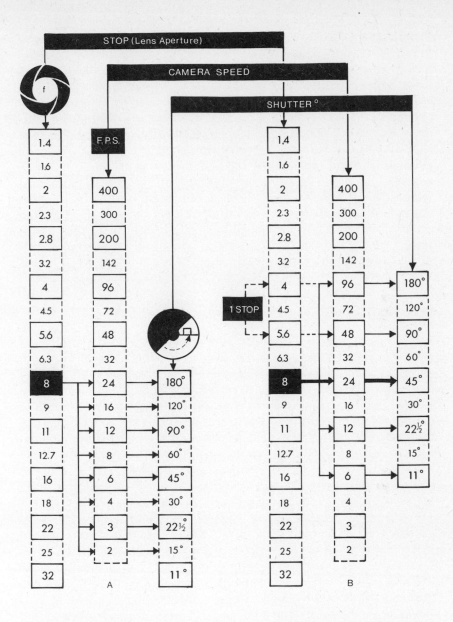

A If the lens aperture is kept constant, eg *f*8, as the camera motor is slowed down from 24 fps to 2 fps, the shutter will be reduced progressively from 180° to 15° in order to maintain constant exposure. This scale can also work in reverse in those cases where the shutter remains fixed and the compensation is done by stopping down the lens iris— the appropriate *f* stop is indicated in the top column.

B If the camera motor is to be speeded up during the shot from 24 fps to 96 fps, then the camera shutter must be set to at least 45° at the start, in order to be able to compensate two full stops.

15

be synchronised with the change in speed of the camera motor. Since the variable speed motors are DC type, their speed is determined by the voltage fed to the motor and a voltage/speed indicator is usually incorporated as well as some form of rheostat control. Alternatively, the DC current can be fed via an independent rheostat to the camera motor. A servo system effects the necessary compensations on either the shutter opening or the iris, as the rheostat control wheel is turned. In those circumstances where the changes in speed are gradual and protracted, the operation can be carried out manually. Altering the iris setting (f stop) results in inevitable changes in the depth of field and should be avoided when such changes are likely to make an appreciable difference to the photographed image. On the other hand, varying the shutter setting does not affect the lens performance and the f stop remains unaltered throughout the operation.

Superimpositions

A white caption superimposed on a live scene is perhaps the most common optical effect that any viewer has seen. In fact it is so common that it is taken for granted, not only by the public but by most film technicians (not to mention producers). It seems hard to believe that such an apparently simple, harmless thing as a white caption 'super' could be the cause of so much aggravation among the post-production people. (The coloured supers have been known to cause near heart failures to the uninitiated.)

In reality, the white superimposition is simple and, as optical effects go, perhaps the simplest. Nevertheless it requires both *planning* and *patience* (the two P's of optical effects).

If the white caption is to be 'supered' on a live action scene after the scene has been processed, it will be necessary to duplicate that entire scene in order to produce a composite negative which has both the scene and the superimposed caption on it. Furthermore, other scenes in that particular sequence may also need to be duplicated in order to maintain the colour match between scenes. If, on the other hand, the white 'super' can be added to the original negative before it is processed then this in-camera effect would save the need for duplication of the negative and the composite image because, as it is first generation, it is of the highest quality.

The white super (on black background) is photographed on the same negative as the live scene before the film is sent to the laboratory for processing. This obviously necessitates two runs through the camera but it is quite immaterial which element is photographed

16

first. The white super is overexposed by one f stop relative to the exposure 'norm' calculated from the incident light reading of the artwork. If the exposure for the live scene has been calculated in the same way, then the elements will be well matched. You must ensure that the black of the caption background does not photograph at all and that no other stray light reaches the lens, as this degrades the live action image. The caption artwork is best prepared photographically on a *Kodalith* – a high-contrast sheet film. This is then 'backlit' so that only the clear lettering is visible; the dense black of the surrounding area ensures that no stray light reaches the lens. (*See* Backlight.)

Alternatively, if the captions are hand-painted or transfer-lettered, it is best to use a glossy black background (paper and cards with this type of surface are available from art shops). With a glossy black background it is essential to use polarised lighting to ensure that the background does not reproduce over the already exposed frame area. (*See* Polarised lighting.) Ordinary matte black is not suitable for this purpose because it reflects too much light when the caption is overexposed. The overexposure of the white area ensures that the negative is 'burnt' into the area of the title and therefore produces a dense black on the negative. (Gross overexposure, however, makes the edges of the caption appear fuzzy.) The image of the background scene is completely destroyed in the area of the title so that there is no overlap.

The normal procedure for this kind of operation is to make a sync mark at the head of the shot. The camera frame counter should be zeroed with the sync frame in the gate. If the super is to appear at a specific point and some way into the shot, then a stop-watch is used to measure the time from when the camera started running to that particular point in the action. Alternatively, some-one could be given the task of keeping an eye on the footage counter. In either case the precise position for the super can be determined to within 10 frames or less. Obviously, this is not accurate enough for some types of supers but for the vast majority it is quite satisfactory. The superimposition does not have to be done at the same time. It is wiser to take several safety takes, all with separate sync marks and all broken off and unloaded into clearly marked cans. In fact, the second pass does not even have to be done in the same camera if another is already set up on a suitable rig for shooting captions. On the other hand, a rostrum camera or an optical printer can be used for the second pass. Additional refinements can then be added to the caption such as a *fade in, fade out, focus pull* movement, etc, and the finished result is still a first generation negative.

Placing the super

A white super burns in most efficiently over those areas of the background where the tonal values in black-and-white terms are mid-grey to black; lighter backgrounds do not provide enough contrast for the white super. When composing the background shot these considerations must be borne in mind. An aid to accurately positioning the super is to trace imaginary lines between certain points on the frame. You can draw these out on a piece of paper with a clear indication of the area which the white super is to occupy.

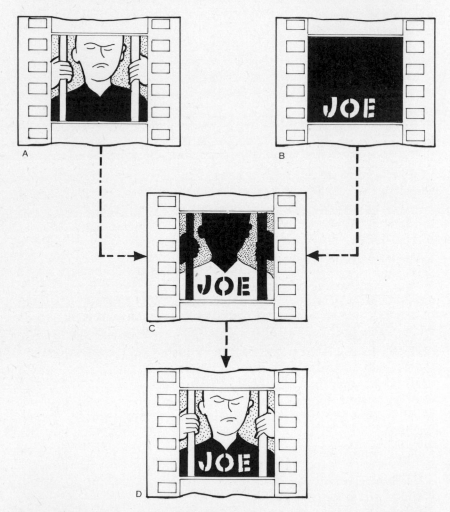

Superimposed caption. **A** Background scene exposed on the first run through the camera. **B** White caption on black background exposed on the second run through the camera. **C** Composite negative with caption 'burnt in'. **D** Positive print.

18

In the case of a static set-up, the background take should be allowed to run a few feet longer than required, so that a few frames cut off the end can be used for dip-testing. Colour films can be processed in a small tank (as used for still photography) with the same developer as black-and-white films. An image produced this way may not be of high quality but it is good enough to achieve a more precise positioning of the super, relative to the background. This clip is placed in the camera gate and projected (*see* Roto-scoping). However, some 35mm cameras are equipped with view-finders which have a provision for registering a frame of film over the ground-glass reticle. This frame can be projected by shining a light through the camera viewfinder so that the caption can be lined up correctly or, alternatively, the lining up can be done visually with the negative clip in position.

In those cases where the precise position of a caption relative to the frame area is established beforehand (such as for a main title), the caption should be photographed in this position, ideally on black-and-white stock, and processed by hand as before. A frame of this negative has a black caption on an otherwise clear frame so that when it is placed in the viewfinder, the background scene can be easily composed around it. Because large areas of frame are clear, the clip can be left in the viewfinder during the take to ensure a perfect match. This approach is very useful even when the super is not to be done in the camera.

Coloured superimpositions

Coloured captions cannot be 'burned in' in the same way as a white caption. An overexposed coloured caption results in a dense black on the negative in the area of the title, which in turn reproduces as white when printed, defeating the object of using colour. On the other hand, a normally exposed colour caption does not obscure those areas of the background where similar or lighter colours are to be found, which results in a ghosting appearance. In addition, if at the points where the colour of the superimposition overlaps with another colour, a third colour is created which is complementary to the other two, in just the same way as when two different pigments are mixed.

The density of a colour is greatly affected by the exposure. An increase in the density of the negative (overexposure) results in a paler, pastel hue of a specific colour, while a reduction in density of the negative (underexposure) produces a stronger hue of that same colour. Consequently, a coloured caption can only be reproduced successfully when it is exposed on raw stock without overlapping

19

with other colours (*see* Matting and inlays.) Only in those cases where there is a large, dark (preferably black) area in the background can a coloured caption be successfully superimposed in the camera.

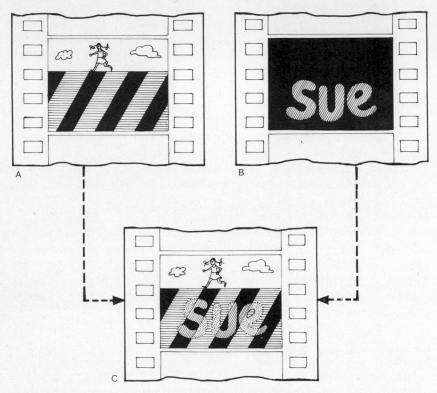

Superimposing colour captions. **A** Background action, black and red stripes painted on the wall. **B** Green caption on black background. **C** Composite. The green caption is clear and is the correct colour where it overlaps the black stripes of the wall but in the area of the red stripes, the caption appears yellow as a result of the mixture of the two colours.

Overlays

When the picture is composed to deliberately include an area of black where the negative will not be exposed, it is then possible to overlay another (complementary) image in that area on a second run through the camera. In both cases the pictures are exposed normally because each image is photographed on an unexposed section of the film. Obviously, great care must be taken in the composition and the lighting of such an overlay to avoid overlaps. The choice of the subject is all important as some are more suitable for this type of optical effect than others.

Double exposures

When two scenes are photographed on the same negative in such a way that they deliberately overlap each other the result is a double exposure. However, photographing two scenes of roughly the same

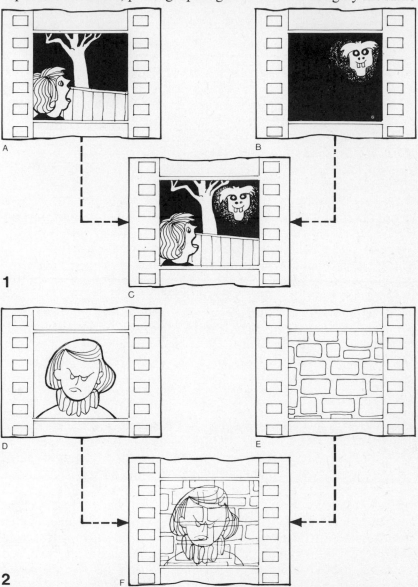

1 Overlays. *A* and *B* are two different scenes exposed on the same negative in two successive passes to produce the composite *C*. Both scenes have large areas of black.
2 Two scenes of average density (*D* and *E*) are exposed in succession on the same piece of negative but at 50% of normal exposure to produce the composite *F*.

average density over the whole frame area, at normal exposure for each scene, would result in a very dense overexposed negative. If each scene is exposed for the normal exposure time, say 1 sec, on the same piece of film then the negative receives 2 sec exposure, i.e. twice the ideal, it is overexposed by one f stop. Therefore each scene must be photographed at less than its normal exposure. The reductions in exposure times will depend largely on the balance required between the two scenes: if a 50:50 balance is required then the exposure of each scene is cut down by 50%. In practice, the exposure of each scene needs to be reduced by one f stop. This can be accomplished by changing the iris setting of the lens, halving the shutter opening, or placing a 0.3 ND filter in front of the lens.

Very often one scene is required to stand out more than the other, in which case the ratio between the two exposures would be altered as required, e.g. 40:60, 75:25, etc, depending on the exposure latitude of the film stock used.

Excessively light or dark areas within a frame can be a problem in double exposure because of the danger of certain areas burning through while others remain underexposed. Scenes with a reasonably uniform distribution of middle tones are most suitable. Too much detail in both scenes can also be very confusing. In addition, camera movement in one of the scenes may produce a separation between the two elements. Camera movements during a double exposure can be very effective but as a general rule of thumb it is better to keep one element static if the other is panning. When there is camera movement in both shots great care must be taken to ensure that these movements are complementary to each other.

Registration

In-camera optical effects can only be executed if the registration system of the camera is of a very high standard. All cameras employ some method of registering the film frame in the camera gate while it is being exposed. In some cases this is done by the intermittent claw movement alone. However, for optical effects, only cameras with the highest standard of registration are really good enough. These cameras employ registration pins which engage the film sprockets during the exposure, holding the film still before the pull-down claw moves it forward for the next exposure.

Without these registration pins the film tends to 'weave' when it is projected. This is not usually noticeable for normal shooting but when another element is added to the same negative (such as a supered caption) the weave becomes apparent because one element is seen to move against the other. A certain amount of weave is

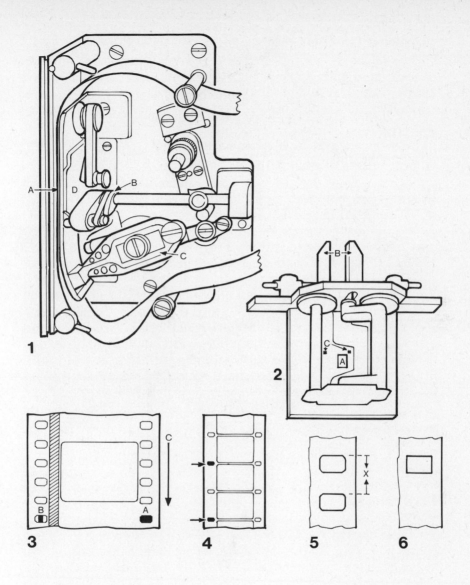

1 Moving pin registration (Mitchell). *A* Aperture plate. *B* Moving pins. *C* Pull-down claw. *D* Pressure plate.

2 Fixed pin registration (Bell and Howell). *A* 16 mm aperture. *B* Shuttle mechanism driven by a cam. *C* Fixed pins.

3 35 mm film. *A* Position of full fitting registration pin relative to frame area. *B* Vertical fitting pin. *C* Direction of travel.

4 16 mm film. Register pins are located along one side only.

5 Negative perforations. *X* Perforation pitch.

6 Positive perforations.

acceptable if the same camera is used for both passes because by engaging the same perforation, the movement may produce the same weave on both runs which would be less noticeable.

Fixed pin registration

Fixed registration pins are actually attached to the gate aperture plate. The transport mechanism is designed to advance a frame of film and place it over the pins. At the end of the exposure the intermittent movement lifts the film up from the registration pins and pulls down the next frame. This is the Bell and Howell registration system which is used on many high precision cameras specially designed for optical effects work, and is also known as the clapper gate or the shuttle gate. It is most suitable for running at slower speeds and widely used on rostrum and optical printer cameras.

Moving-pin registration

Moving-pin registration, known as the Mitchell type, is used on all Mitchell cameras. It employs two pins which move down to engage the film perforations at the start of the exposure and move up again at the end of the exposure so that the next frame can be brought into position by the pull-down claw.

Steady test

The steadiness of a camera depends on the efficiency of its registration mechanism. This can be tested by photographing a grid made up of white lines on a black background which extends beyond the frame area. On projection, the film should be racked up so that the frame line is clearly visible. Any unsteadiness will be indicated by a relative movement of the vertical white lines at the bottom of one frame and those at the top of the next. Steadiness for multiple passes through the camera is checked by photographing the grid twice; for the second run the grid is moved diagonally to give sufficient separation between the two images. On projection the two images of the grid move against each other if the camera is unsteady.

Film pitch

Other factors contributing to unsteadiness can be film shrinkage, damaged or inaccurate perforations, or inaccurate setting of the camera's intermittent claw movement for the particular 'pitch' of

24

the filmstock used. Film pitch is the distance between the leading edges of two adjoining perforations. Essentially there are two types – short pitch and long pitch – just as there are two types of perforations – positive and negative. Camera films are normally punched with negative 'short' pitch perforations. Some cameras have the facility for making fine adjustments in the pull-down mechanism to accommodate small changes in the perforation pitch of different batches of filmstock. When the pitch setting is wrong the film makes a 'picking' noise as it goes through the camera gate.

In-camera fades

If the camera is equipped with a variable shutter it is a relatively simple operation to produce fades. A *fade-in* is done by gradually opening the variable shutter from the fully closed to the fully open position during the shooting. A *fade-out* is produced by the same operation in reverse. The shutter mechanism can be motorised so that the entire operation is done smoothly and by remote control. Most of the fades for a film can be done at the time of the shooting, i.e. in the camera, instead of at the post-production stage. Of course, it is easier to sit back and look at the print of a scene and choose the precise frame where the fade should start and end and very often this approach is absolutely essential. However, in such a case the fade can only be accomplished by the duplication of the entire scene or by A and B roll printing (*see* p. 46). More often than not a fade is dropped altogether under the pressure of rapidly advancing deadlines.

Mixes (dissolves)

It is common misconception to assume that a *dissolve* from one scene into the next is produced by overlaying a *fade-out* and a *fade-in* of the same duration. If this were to be done there would be a noticeable drop in the exposure in the middle of the transition. The fact is that a *fade-in/out* and a *mix-in/out* follow entirely different curves. During a *mix (dissolve)* the exposure of the negative must remain constant, consequently the exposure loss with each progressive step during the *mix-out* on the outgoing scene has to be made up in corresponding proportions during the *mix-in* in the incoming scene. The perfect *mix* is absolutely invisible when both *mix-out* and *mix-in* are made over the same static, unchanging shot. The trouble with the 'in camera' mixes is that, although many live action cameras are equipped with variable shutters, very few of them have been adapted to perform the task of mixing successfully.

25

Apart from a selection of mix (dissolve) lengths such a device must include a positive method for activating the mix either by pre-setting or by manual operation. The start of the mix-out and mix-in must be overlapped accurately. Of course this is much more easily accomplished when shooting stop-frame.

Using the 'in-camera' mix (dissolve)

Mixes are most often used to link different scenes which may be shot at different times and on locations many miles apart. This is one of the main reasons why 'in-camera' mixes have not become as

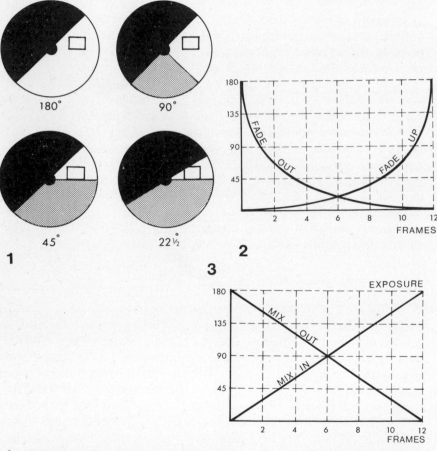

1 Variable shutter: 180°=normal exposure; 90°=half normal exposre (add 1 stop); 45°=quarter normal exposure (add 2 stops); 22½=eighth normal exposure (add three stops).
2 A fade up and fade out curve superimposed.
3 Graph showing mix (dissolve) in and mix out. When mixing, the shutter angles must add up to the same (usually 180°) for each frame.

popular as might be expected. Although it is possible to shoot a scene with a mix-out allowing enough stock for the next scene and then canning it up until the next scene can be shot, this is rarely attempted in practice. There is also the question of timing, which is more easily determined in the post-production stage as each scene may require a different number of takes.

There is one effect which is ideally suited to the 'in-camera' approach: characters or objects can materialise in a scene or disappear into thin air. Other effects can be added to the same negative on a second run through the same camera, or later on a rostrum camera or an optical printer, with the help of a dip-test. This means, for example, that a glowing halo can appear around a spaceship as it vanishes into thin air.

Superimpositions, overlays, and double exposures (*see* p. 62) can often be introduced and/or lost with the aid of a mix or a fade.

Sectional masking

As we have seen earlier for overlays, it is necessary that a section of the frame remains unexposed so that the overlay can be accommodated, without overlap. Very often, a relatively dark area may have some detail in it which is likely to register on the negative in the area where the overlay is intended to go. It is best to mask off that particular area to ensure that that portion of the film remains unexposed. This can be done by placing a mask either in front of the camera lens or in the camera gate itself. In either case the mask should be cut to correspond roughly to the natural outlines of the black-out area.

Mask in the gate

Many cameras have a slot in the gate which can be used for inserting gelatin filters or masks cut out of thin black paper. Masks with various degrees of cut off, made out of thin metal plate, are often supplied with the camera, and they are easier to use in this way than masks cut out of paper. The closeness of the mask to the focal plane means that the edges appear sharp (hard edge), particularly when the lens is stopped down.

Mask in front of the lens

A rigid matte box is often sufficient to support a mask in front of the camera lens. The edge of such a mask is out of focus because of its nearness to the lens. This 'softness' of the edge changes consider-

ably at different iris settings and it is advisable to check the mask line-up at the f stop which is going to be used for the actual take. The out-of-focus type of masking is usually required for masking off corner sections of the frame, but sometimes a central area of frame may need similar treatment. The mask is then stuck to a piece of clear glass of good optical quality which is inserted in the matte box slot normally provided to hold glass filters. A bigger

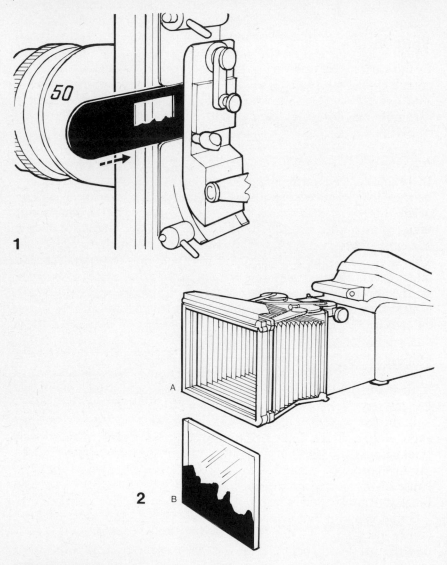

1 Mask inserted in the camera gate.
2 *A* Matte box can be used to carry masks attached to clear glass (*B*).

28

matte box allows a larger piece of glass to be used which makes cutting and lining-up much easier. In special cases the mask can be stuck to a free standing sheet of glass placed some distance in front of the camera (*see* Glass shots). A matte-box-mounted mask has the added advantage that it stays in a fixed position relative to the frame when the camera is moved.

Split screen

In the earlier examples of overlays, no masking was required to ensure that a particular area of the frame remained unexposed. The overlay scene which was photographed on a separate run through the camera was assumed to be on a black background so that the image could be photographed in the appropriate section of the frame while the rest of the frame remained unaffected. In practice this second run might also need some form of masking. In both these cases the masks were really only auxiliary devices because the two scenes already complemented each other. However, when the frame area is split up into various sections which are then exposed each on a different run through the camera and then correctly matched, masks and counter masks have to be used. This is, in effect, the basic requirement for a split screen. When the matte box is used to carry the mask it is possible to vary the shape of the mask edges from the purely geometric shapes made by straight lines. As both the first mask and its counter mask are cut out of the same paper, it is relatively easy to match them up when one replaces the other on the glass. Consequently, the split line can be made to match the specific outline of a shape within the frame. If the masking is done in the gate, however, the choice is limited to geometric cut-offs of specific proportions of the frame, e.g. half-frame, (vertical, horizontal, diagonal), one-third, etc.

It should be remembered that if the edges of the masks overlap each other a black line is produced between the two images, its thickness corresponding to the amount of overlap. When the masks are mismatched the other way, a white line is the likely result because of the overexposure of the area in between. Of the two, the black margin is more acceptable and is often used deliberately.

Some cameras have built-in adjustable masking blades which can be used to mask out sections of the frame. They consist of a pair of horizontal and a pair of vertical blades. Often an adjustable iris is included which can produce circular masks of varying sizes and which can be moved to any position within the frame.

Effects filters

Graduated density filters. The most common types of graduated density filters are neutral density filters which are graduated from clear to a specific density. The transition area between the two sections of the filter can be fairly narrow, dividing the filter into two halves – one clear and the other of a specific neutral density. The borderline area can be used to line up with the horizon in those cases where a very bright sky needs to be darkened to create a more dramatic effect. Alternatively the transition can be progressive across a much wider area.

Graduated density colour filters can be used to put some life into a bleak sky or to enhance a sunset.

Fog filters. Fog filters are made out of a multitude of finely etched spots in a glass surface which is then protected by another clear glass. The light rays striking these spots are refracted in various directions and so produce a fogging effect over the entire picture area and a desaturation of colour. These filters are available in varying strengths.

Diffusion filters. Diffusion filters are made out of tiny particles sandwiched between two pieces of optical glass. They are very useful when a deliberate softening of the overall image is required. They are also available in varying strengths.

Low-contrast filters. Low-contrast filters are intended to reduce the overall contrast of a scene by the introduction of a small amount of fogging and diffusion.

Star filters. A point of light seen through a star filter has the appearance of a star with several rays projecting from it. The precise number of these rays and their geometric shape depends on the number of finely etched lines on the star filter.

Gauzes (nets). Silk scarves provide the best material from which gauze filters can be made. The effect is determined by the weave of the cloth and the number of layers used. Although black materials are most commonly used, it is possible to use white gauzes (with an added fogging effect) or even coloured, where this is appropriate. The general effect of gauze filters is a combination of star effects and diffusion.

Polarising filters. Light is made up of electromagnetic waves vibrating at high frequencies. Each light ray moves in a particular direction away from the source, continuously vibrating in all directions around its axis of travel. Polarising materials possess properties which permit light waves vibrating in one specific plane to pass through while the others are absorbed. Put a sheet of polarising material in front of a light source and the light passing

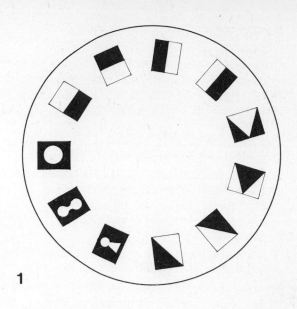

1

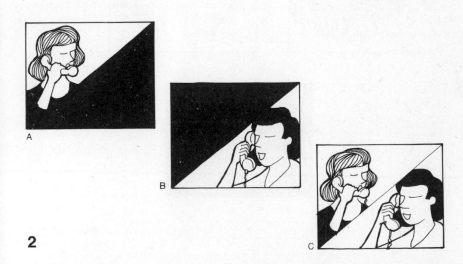

A

B

2

C

1 An effects disc built into the camera with a selection of masks. **2** The split-screen composite *C* is produced by shooting scenes *A* and *B* through their respective masks.

31

Light can also be polarised by reflection. When the sun's rays fall on a highly reflective surface they become polarised. A polarising filter on the camera lens eliminates this reflection when it is rotated so that its axis of polarisation is at 90° to the polarisation axis of the reflected light. Sun glare on the surface of water can be eliminated in this way so that objects in the water can be seen clearly. Unwanted reflections in glass windows can also be lost in this way.

Artificial light sources also can be polarised in order to eliminate unwanted reflections. Large polarising sheets are placed in front of the light sources, with their polarisation axes in the same plane, and a polaroid filter over the camera lens with its axis at 90° to the others. Unwanted reflections, dust particles, etc, are eliminated in this way. This set-up is particularly effective where a subject is photographed against a black background which needs to be a perfect, even black.

Polarising filters for use in front of the lens are made from thin polarising materials sandwiched between two sheets of optical glass. Those used in front of the lights are mounted on a plastic base. They are available in varying strengths of polarisation. However, the most efficient ones also produce colour distortion and should be used only in those cases where colour is not important or can be corrected sufficiently; type HN 38 is normally recommended for photographic use. The use of polarising filters produces an apparent increase in contrast.

Optical flats. Optical flats are pieces of high quality glass, free of any distortions or imperfections. They are used to support masks, bits of coloured gelatin, etc. Vaseline smeared selectively on an optical flat produces a diffuse vignette effect in those areas seen through the smear while the rest of the image remains unaffected.

Ripple glass. Pieces of imperfect glass with accidental or deliberate distortions can be very effective particularly if they are rotated or moved around in front of the lens during the shot. Commercially available patterned window glass can be used very effectively for this purpose. The distortions produced in this way are often very great, so that the original scene is hardly recognisable. Where possible, it is wiser to shoot the scene normally and then introduce the distortion afterwards. If the action allows it, the end of the normal part of the take can be overlapped with the beginning of the distorted part by a dissolve in the laboratory (*see* A and B roll printing). A change of focus is also required because the ripple glass is acting as a dioptre lens, be it a very imperfect one.

Clear plastic. Shooting through a large sheet of clear plastic while it is twisted and bent can produce very interesting distortions.

1 Vaseline smear on clear optical flat produces a selective diffusion effect.
2 Ripple glass produces an effective distortion or break up of the image.
3 Twisted clear plastic is an alternative method of producing image distortions.

Prismatic lens attachments

Prismatic lens attachments are used to create a multi-image effect, in which the number of images depends on the number of facets in the attachment. When the attachment is rotated, the peripheral images rotate around the central one. Kaleidoscopic effects can also be created by shooting through a tube containing three or more front-silvered mirrors; when the tube is rotated the central image remains static. Another prismatic attachment makes it possible

35

to rotate the full image through 360° around the lens axis; the same effect can also be produced by a special arrangement of front silvered mirrors. Other prismatic devices enable the image to be 'flopped' or reversed laterally.

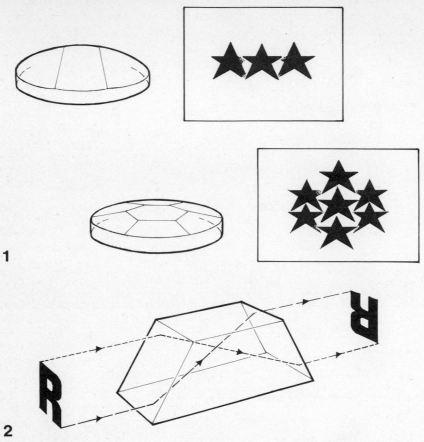

1 Prismatic lens attachments to break up or distort the image.
2 An image-rotating prism.

Split dioptre lens

The split dioptre lens attachment is similar to the normal dioptre lenses which are used for extreme close-up photography; it is, in fact, half a normal dioptre lens. It can be positioned in the frame to enable the photography of a normal scene in one part of the frame and an extreme close-up in another. The join between the two areas of frame should be positioned where it is least likely to be noticed.

Attachments

Periscope attachment. Shooting from a fixed wing aircraft is usually done by means of a periscope attachment. It is also used in other circumstances where it is physically difficult to shoot directly with the camera, such as for taking extremely low angles from ground level, through a window, close to a wall or some other

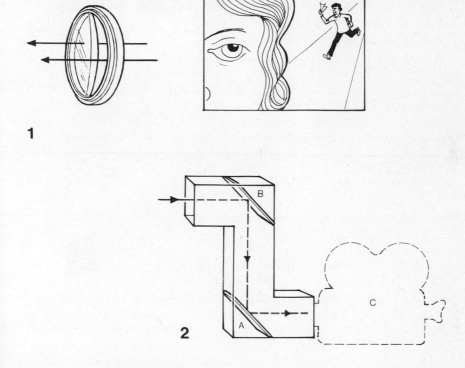

1

2

3

1 Split dioptre lens in use.
2 Periscope attachment. *A* and *B* front-silvered mirrors. *C* Camera.
3 Snorkel attachment. *A* Front lens. *B* Front-silvered mirror.

37

obstruction. This attachment is limited to fairly narrow angle lenses.

Snorkel attachment. This is a very sophisticated periscope. It is made up of a long tube which is attached to the front of the camera. Apart from the normal camera lens there is also a second lens at the end of the tube. Between these two lenses and lying inside the tube are a field lens and a relay lens which enables the camera lens to pick up the aerial image produced by the front lens. Immediately in front of the front lens is a front-silvered mirror normally set at 45° to the lens axis. This mirror can tilt up and down and rotate to give extra flexibility to the system. The great advantage of this system, apart from the flexibility, is that much greater depth of field is possible than with ordinary periscope attachments. The depth of field is determined by the front lens which can be a wide-angle lens. The camera is mounted on a transport mechanism on the gantry which allows it to be moved by remote control in any direction. A television camera attached to the camera viewfinder system is an additional help in lining up the shots.

This attachment is particularly useful for shooting miniatures; it can track along narrow corridors, hover over a miniature town and dive into a glass of water.

Mirror effects

Ghosting. A two-way mirror placed in front of the camera lens can be used to reflect a second scene and so overlay it over the master scene which the camera is photographing directly through the mirror. This is the easiest method of introducing a 'ghost' but, naturally, the area behind the actor must be blacked out. By twisting the frame holding the two-way mirror, it can be made to shatter and so cause the 'ghost' image to disappear. Shooting at high speed and/or in reverse enhances the effect further. Two-way mirrors are available in various thicknesses and with different transmission-to-reflection ratios. For the above example a high transmission and low reflection mirror is most suitable because once the mirror is broken there is little change in the brightness of the scene being photographed and no compensation is necessary. In fact, an ordinary piece of good quality glass has sufficient reflectivity to act as a two-way mirror in this case. The brightness of the reflected image can be increased by lighting the two images in the opposite ratio to the transmission:reflection ratio of the mirror.

Front-silvered mirror. A good flat piece of glass which has been silvered on the front reflects an image without the creation

38

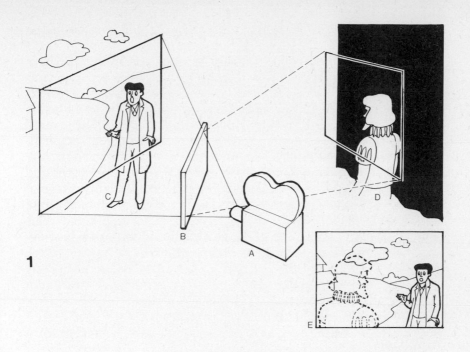

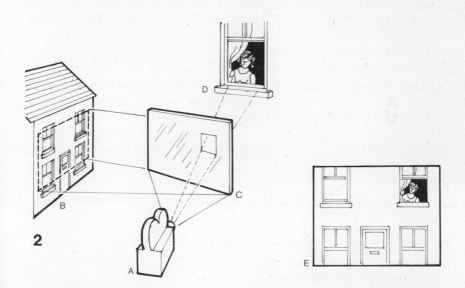

1 Ghost effect. *A* Camera. *B* Two-way mirror. *C* Actor on set. *D* Ghost actor in front of black backing. *E* Composite.
2 Mirror matting. *A* Camera. *B* Miniature. *C* Front-silvered mirror with clear section. *D* Live action set. *E* Composite.

of secondary images, as is the case when the silvering is on the rear of the glass (as in conventional mirrors). Breaking a full front-silvered mirror creates an interesting transition from one scene to another, particularly when it is done at high speed. A large mirror placed at some distance from the camera can be blown up by explosives, creating the illusion that the actor reflected in the mirror has been blown up.

Matting with front-silvered mirror. A front-silvered mirror is often used to enable a live action section to be inserted into a miniature. This is done by placing the miniature at right angles to the lens axis so that it can be seen by the camera via a front-silvered mirror set at 45° to the front of the lens. The silver is removed from the mirror in the area where the live image is to be inserted. The new image can now be seen through the clear glass and has to be lined up and lit so that it matches the miniature.

Glass shots

Glass shots are perhaps the most popular and still most widely used of all in-camera effects. A large pane of good optical quality glass is placed some distance from the camera. Beyond it, there could be a partially completed set in the studio, whilst the non-existent parts of the set (anything from a domed ceiling to foreground pillars) are painted on the glass. The camera remains in a fixed position for this type of shot. In certain cases, panning and tilting the camera are possible if the nodal point of the lens is in the true centre of pan and tilt of a specially designed nodal head (more about this later). Glass shots are made both in the studio and on location where certain features in the landscape need to be eliminated or some others added. Matching colour and lighting, particularly the position of shadows in the case of exteriors, means that the shooting of the composite, which may include an army of extras, has to be done during a specific time of day.

In certain circumstances it is possible to use large colour photographs, which are cut out and stuck on the glass. The scale and positioning of these photographs has to be carefully calculated so that they match the real parts of the scene.

A variation on the glass shot is to shoot the live action element, first blacking out unwanted areas of the set with masks in front of the camera. Several takes are made of each scene but only one is sent for processing and printing while the rest are kept in cold storage. A clip from the processed take is placed in the camera and projected onto a large piece of glass. The matte painting can then be done on the glass, matching what is already on the film.

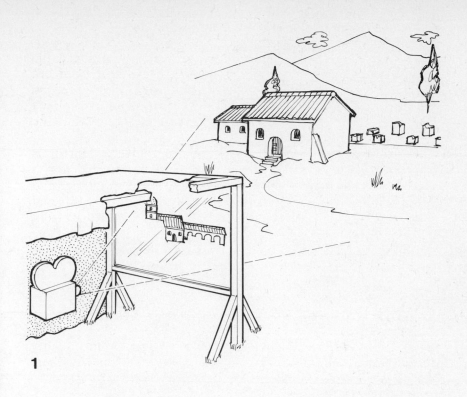

1 Glass with additional features painted on it, placed between camera and screen.
2 Composite scene of glass shot.

Colour temperature

In order to ensure the correct reproduction of colour it is essential that the colour temperature of the light source should match the specifications of the film emulsion. This is usually represented in kelvins (K).

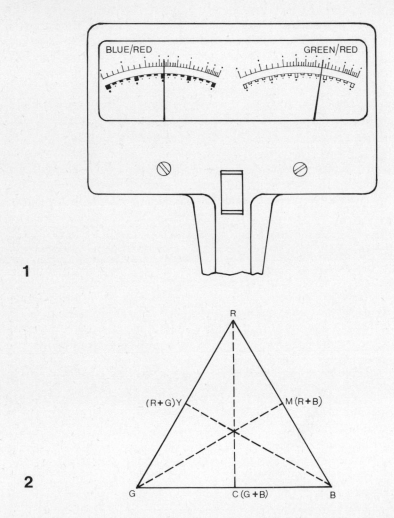

1 Colour temperature meters have a photocell and two filters, usually red and blue. Some models use three filters — red, blue and green and are more accurate. Relative proportions of red and blue (or red blue and green) light are indicated on a precalibrated scale and can be converted to kelvins or mireds. Some models give a direct reading in kelvins as well as a recommended filter for a specific type of colour emulsion.
2 Triangle of primary colours with their corresponding negative colours.

42

Most colour negative movie stock is balanced for 3200 K lighting. This is the colour temperature of studio lamps (tungsten halogen). A colour temperature meter is used to check the colour temperature of the light source. It indicates the degree of correction required – which is accomplished by the use of coloured filters. These are made of gelatin or acetate. They are available in varying densities from 0·05 to 0·50 in cyan, magenta, yellow and red, green and blue. A variation in voltage supply produces changes in colour temperature of the light source; and it can also change towards the end of a bulb's life. It is advisable to keep a log (or just notes in a diary) when the bulbs are changed so that this can be done at regular intervals.

Colour correction makes it possible to produce subtle alterations to the colour balance of a scene. This may be needed, for example, if a slightly off-colour still or transparency is to be used. Correction is usually best done at the printing stage in the laboratory, but this is not always possible because two scenes may be linked together with a dissolve or other optical device. In which case the correction has to be done in the camera. In the absence of any other aids the cameraman has to rely on his own perception of colour balance; if one of the scenes has correct colour balance then the second one should be placed alongside it and both lit evenly. The scene which needs correction is examined through a series of colour compensating filters and compared with the correct one until a suitable filter is found.

Variation in exposure is yet another factor that affects the accuracy of colour reproduction. If there is time, the wisest course is to do a series of wedge tests using filters at varying exposures.

Exposure aids

You can use a scene containing the full range of neutral colour tones from white to black. But as such a scene is not easy to come by you normally use a suitably stepped grey scale. A constant (fixed) setting is chosen for all elements except one. That is progressively altered (wedged) across the range where the optimum exposure is expected to be.

For example, you may fix (*and record*) film speed rating, lighting, camera speed and shutter angle. Then the lens aperture is altered through a suitable range in fractions of an *f* stop. The film is processed normally and a print is ordered at *middle light;* in black and white this is 13, and in colour printing it is *25 across* – 25-25-25 – indicating equal amounts of the three primary colours.

GREY SCALE

2%	4%	10%	18%	38%	60%	93%

1

COLOUR CHART

Red	Green	Blue	Yellow	Cyan	Magenta

2

1 Grey scale, which is a series of neutral colour patches of progressively greater density. It is useful for exposure determination.
2 Colour chart made up of suitable colour patches. For colour film it is essential to know the effect of exposure on various colours. Such a chart helps to reveal stock defects, exposure errors, lighting and processing problems in colour.

This gives a basic standard exposure level, from which you can depart for specific reasons.

A grey scale may have a colour cast when printed at 25-25-25. The need to print it on say 28-24-23 to get rid of the cast does not indicate that the negative was incorrectly exposed (the average is still 25) but it does mean that the colour reproduction is not accurate. If the original artwork was truly neutral, probably the colour temperature of the lights does not match the balance of the film stock (with whatever filters were used).

A minor deviation is not serious in itself because it can always be corrected in the printing. However an optimum standard of colour reproduction is the only basis for calculating colour deviations from the norm either in the shooting or processing.

A colour chart in conjunction with a grey scale is used to determine the appropriate colour correction and establish a basic standard filtration for the lights. A colour temperature meter will give a good indication of the degree of colour bias, but a wedge test, processed normally and printed at 25-25-25, is the best way of finding exactly the filters needed. This test is done like an exposure wedge. Exposures are made through a series of colour compensating filters at a number of lens apertures covering a range of 1 or 2 stops around the calculated exposure. Colour compensating filters absorb the light proportionally to their strength (density), so a colour correction wedge has to be linked with exposure.

2　Laboratory effects

It is well worth remembering that a number of basic optical effects such as fades, mixes and even double exposures and super-impositions can be done in the final printing stages in the laboratory. This is particularly important where relatively short film lengths are involved such as in the case of advertising films, title sequences, etc.

A and B roll printing

The negative is cut and assembled in two rolls in such a way that the two sections of the film which are to be printed together in the form of a dissolve or a double exposure are laid opposite each other with matching synchronization points at the start of each roll. Black spacing is used in between the scenes on each roll to make up the required length.

Starting points of fades and mixes are determined so that they can be done automatically during the printing procedure. The rolls are printed in sequence on the same piece of raw stock using the same sync point. In 16mm work the negative is mostly in A and B rolls anyway in order to eliminate the frame joins which appear when scenes are cut together on the same roll; consequently A and B roll printing is used a great deal in 16mm production.

A and B printing is not as popular in 35mm production although it is equally effective. Naturally, if there are only one or two mixes or fades in an entire reel it is not very practical to neg cut and print the entire reel as A and B. But even here a relatively recent development allows for these opticals to be done without the necessity

for A and B roll neg cutting. All the scenes are neg cut on the same roll but, at the end of a scene which is meant to fade out or mix out, black spacing is inserted which is equal to the length of the optical required. The negative roll continues to move in the forward direction but, when the mix-out has been completed, the raw stock is automatically wound back the length of the black spacing and then the mix-in on the incoming scene begins.

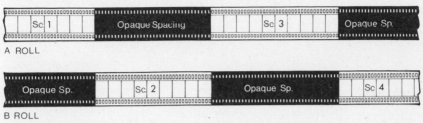

A ROLL

B ROLL

1

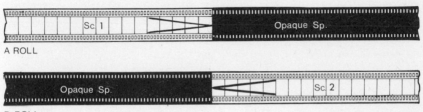

A ROLL

B ROLL

2

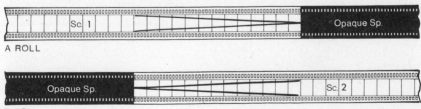

A ROLL

B ROLL

3

1 A and B roll printing.
2 Fade out on A roll followed by a fade in on B roll.
3 A dissolve (mix) from A roll to B roll.

Naturally, this sort of operation can be done only by an optical step-printer while the normal A and B roll printing, which involves two full passes through the printer, can be done by continuous rotary contact printing (*see* Printers).

The importance of A and B roll printing is very often overlooked. Here is an optical effect produced at the second generation but equal in quality to a first generation in-the-camera optical because that, too, has to go through a printing stage to arrive at a positive image for projection. Very often a complex optical sequence can be simplified and even saved by eliminating one duplicating stage in this way. In the case of theatrical release printing, a number of CRIs are normally made from the original cut negative and release prints are made from these. Laboratory opticals can be incorporated at this stage avoiding one extra generation of dupes.

Printers

Rush-prints (dailies) and final release prints are normally printed on continuous rotary printers. The processed negative and the raw stock are held in contact (emulsion to emulsion) by the sprockets of a large diameter drum. The two strips of film are pulled across a slit in the drum which is illuminated by a light source. Colour correction and density changes are accomplished by modulating this light. A series of notches at the edge of the film negative are used to activate specific changes in the grading from shot to shot or even within the same shot when necessary. These notches and the exact printing lights are established in the grading stage; a punched tape is prepared which can then be fed into the printer for these changes to be carried out automatically.

Continuous printers are designed to cope with large footage and the printing operation is done at fairly high speeds, with the film pulled along at a continuous rate. The registration is bound to be less than perfect because it relies on the sprockets of the drum alone to hold the two pieces of film in register. However, the registration is sufficiently good for the type of work for which continuous printing is intended. This method also shows the need for 'short' and 'long' pitch film perforations, because the positive (raw) stock which lies over the negative on the drum needs perforations slightly further apart to accommodate the slight increase in diameter of the drum due to the thickness of the negative stock.

Intermittent, or step printers, operate at much slower speeds than continuous printers because they employ an intermittent movement. The processed negative and the raw stock are held

in contact by register pins during exposure to the printing light. A shutter cuts off the light during the pull-down movement. As most optical work depends on duplicating the original in some way at least once, it is essential to preserve the quality and the steadiness of the original. Optical work is hardly ever done with the original negative, but with duplicates made from that negative because of the risk of permanent damage to the original. The intermittent contact printer (step printer) is very often the first step in this type of work. Intermittent optical printer functions are discussed in detail on page 56.

Forced development

When the light level is inadequate for a normal exposure it is often possible to shoot with a deliberate underexposure of one or two stops. This film must be kept separate from the normally exposed one as it will require forced development by the laboratory. It is also extremely important to state precisely the extent of the forcing required, i.e. one or two stops. Forcing colour negative emulsion by one stop does not create a serious colour distortion but may affect contrast.

3 Duplicating films

There are a number of different stocks which are specifically designed for duplicating and as most optical effects involve one type of duplication or another it is well worth familiarising oneself with the materials available. Although there are other stocks on the market, for the purposes of illustration in this book only Kodak is used. Duplicating stocks are generally punched with negative perforations.

Colour Reversal Intermediate (CRI)

CRI stock is available both in 35mm (type 5249) and 16mm (type 7249). It is used for making direct duplicates of original negatives made on Eastmancolor camera negative stock. A contact printed copy produces a reversal of geometry – (the image is flopped left to right) when the original negative is printed emulsion to emulsion with the raw stock. This can be very useful when a reversal of geometry is particularly called for. Naturally, if the first CRI is used in the preparation of a second CRI in contact printing, then the geometry is returned to normal. With optical step printing this problem does not arise as it is possible to load the projector so that printing is back- (or cel-) to-emulsion and the image is not flopped. However, it should be remembered that negative images are being used when attempting to combine other elements with a CRI.

In some cases, due to the unavailability of optical printers, some laboratories have been known to make CRIs on continuous rotary printers. To avoid the geometry reversal they would run the

50

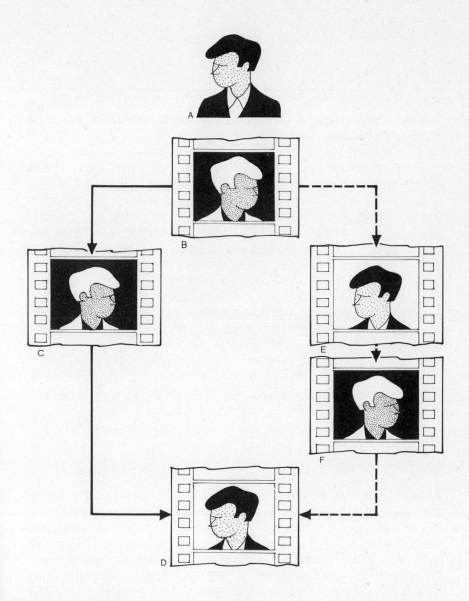

A Scene (before photography).
B Original negative.
C CRI optically printed.
D Print from dupe negative.
E Interpositive.
F Internegative.

original negative cel-to-emulsion with the raw stock instead of emulsion-to-emulsion. Printing through the cel this way produces an overall loss of definition and should be avoided under normal circumstances.

Internegatives EC 5253 (35mm) and 7253 (16mm)

Before CRIs arrived on the scene, most duplicating work was done by the interpositive/internegative method. It is still very widely used in optical work, if not as much for straightforward duplication of negatives. An interpositive is first made in contact with the original negative. This positive image can then be copied again on the same intermediate stock to give a correctly balanced duplicate negative of the original scene. It is during this second duplication stage that an almost limitless number of effects can be created. Working with a positive image is a great advantage. Since the intermediate stock is not intended for direct photography, all other elements to be added to the original scene must also be printed on the same stock in order to maintain the colour balance. In addition to this, interpositive stock is extremely slow in comparison to camera films and requires a great deal of light to produce an adequate exposure. Yet, despite all this it is used in certain specific situations where duplication of a projected scene and directly photographed artwork have to be combined (*see* page 118). Incidentally, this stock has the familiar orange mask common to colour negative materials.

Panchromatic colour separation stock (5296 35mm)

Panchromatic colour separation stock is used for the preparation of black-and-white separation positives from the original negative. These separations represent yellow, cyan and magenta records of the original scene in black-and-white tonal values only. The original negative is contact-printed onto this stock three times – each time through a different colour-separation filter: blue, green and red, respectively. When this procedure is reversed and the three black and white records so obtained are printed onto intermediate film, type 5253 through their respective colour separation filters, the result is a colour duplicate negative of the original. This method offers a lot of scope for colour distortion effects. By deliberately printing the black-and-white master

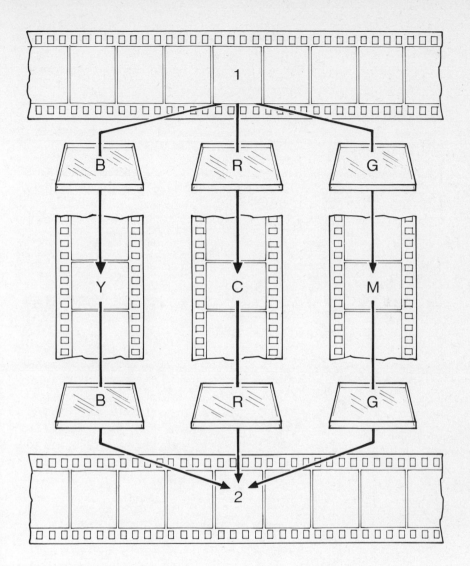

Colour separation.
The original negative (**1**) is printed separately on three pieces of panchromatic film through three colour separation filters (blue, green and red). This produces separate records of the yellow, magenta and cyan elements of the image. Printing through the same three separation filters onto colour negative stock produces a duplicate colour negative (**2**).

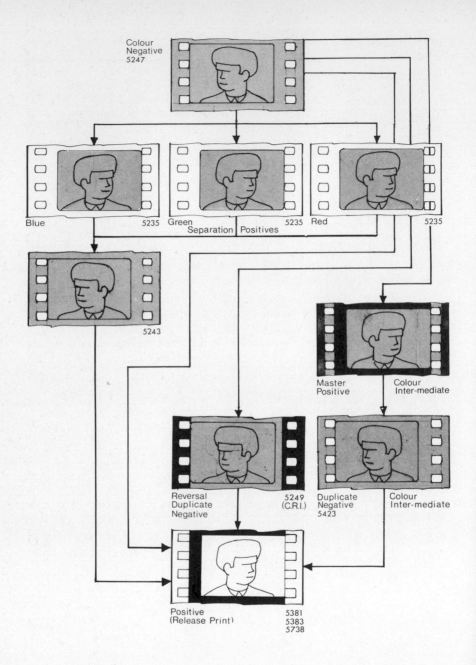

Colour
Negative
5247

Blue 5235 Green 5235 Red 5235
Separation Positives

5243

Master Colour
Positive Inter-mediate

Reversal 5249 Duplicate Colour
Duplicate (C.R.I.) Negative Inter-mediate
Negative 5423

Positive 5381
(Release Print) 5383
 5738

Duplicating methods via CRI, interpositives, colour separation and black and white.

54

positives through the 'wrong' filters onto the intermediate colour stock and by careful manipulation of the intensity of light passing through the primary colour filters, an inexhaustible number of strange colour effects can be created.

Colour internegative

Colour internegative stock is available in both 35mm (type 5271) and 16mm (type 7271) and is used for producing negatives from colour reversal originals.

Black-and-white duplicating stocks

Fine grain duplicating positive stock, type 5366 (35mm) or type 7366 (16mm), is used to produce a black-and-white positive from an original black-and-white negative. When a black-and-white positive is required from a colour negative, then the panchromatic separation stock type 5296, should be used. A black-and-white fine grain positive made on either of these two stocks can then be printed onto fine grain duplicating negative type 5234 (35mm) or type 7366 (16mm), to yield duplicate negatives from which prints can be made.

High-contrast stocks

Monochromatic black-and-white stocks which tend to register tonal values as extreme blacks and whites are very useful in the production of optical effects. It is the difference between the black areas (very dense, practically opaque) and the light ones (clear base only) that make these stocks indispensable when it comes to titling and matting in particular (*see* Making travelling mattes).

4 Optical printer effects

The basic printer consists of a camera head and a light source. The stop-motion motor normally has a selection of speeds and can run backwards as well as forwards and continuously, as well as in stop-motion, without a change in the exposure time. The camera unit is equipped for bipack operation which enables it to run a processed positive (or negative) film in contact with the raw stock. The raw stock is laced up in the normal way with the emulsion side facing the lens while the positive stock is laced up in the opposite way so that the two pieces of film lie emulsion to emulsion. This is very important as printing through the cel softens the image focus. The inner loop is shorter by one perforation at both ends of the camera gate.

As the two rolls of film pass through the camera gate in a frame-by-frame operation they are exposed to the light source and the image on the exposed film is printed onto the raw stock. In this way the basic camera, fitted with a stop-motion motor and bipack magazines, can perform exactly the same functions as a contact step (intermittent) printer. The light reaching the camera gate is regulated by the lens iris or at the light source. In the absence of proper optics a diffusing material such as opal glass or ground glass can be used to create even illumination over the entire frame area. It is important that the lens is set out of focus to avoid the reproduction of the grain within the diffusing material.

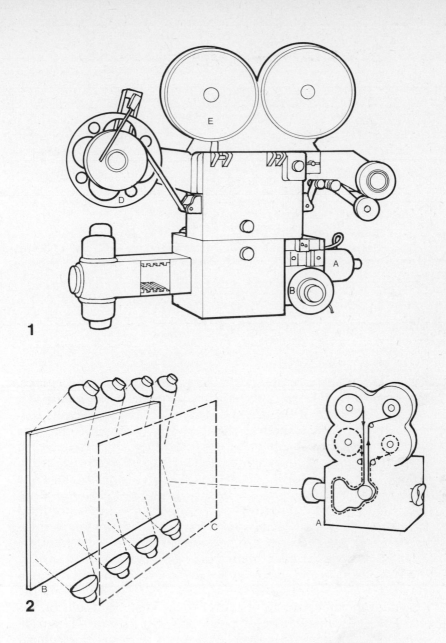

1 Contact step printer. *A* Motor. *B* Mix/fade selector dial. *C* Gate. *D* Duplicating stock. *E* Raw stock. *F* Lamphouse. *G* Filter slots.
2 *A* Standard Mitchell camera fitted with bipack magazines. *B* White board illuminated by a series of lights. Serves as the light source for the step printing operation. *C* Dotted outline of glass frame which can be used to support masks and/or artwork.

The lamphouse

At its simplest, the lamphouse can be a normal light source with a colour temperature of 3200 K. Several easily accessible filter slots serve as supports for colour correction and neutral density filters. The voltage supply to the lamp must be regulated because both the density and the colour of the picture will be affected by voltage variations. The optics in a simple lamphouse of this type vary, depending on the specific application. In general, they are designed to produce a flat, even illumination of the camera gate, for contact printing, and of the projector gate for optical printing.

The condensor system normally includes a heat filter to absorb the heat from the light. However, a dichroic mirror (cold mirror), designed to reflect the light in the visible range of the spectrum and transmit the infra-red, is by far the most efficient way of taking the heat out of the light beam.

Additive colour lamphouse

The more sophisticated printers have a colour additive light source which can change the colour characteristics of the light without the use of colour correction filters. The appropriate colour combination of blue, green and red is coded on punch-tape which automatically produces the desired colour and density at appropriate points during the printing procedure.

There are two basic designs of colour additive lamps:
1. The beam from a single light source is passed through beam-splitters to produce three separate beams of light. Each of these three beams of light is passed through a colour separation filter: blue, red, or green. A second set of beamsplitters combine the three separated light beams again into one beam of integrated light. By manipulating the light valves governing each separate beam, the intensity of each of the three primary colours can be controlled, producing a change in the colour temperature of the light reaching the film.
2. Another method employs three different light sources. The light from each lamp passes through one of the colour separation filters (or the lamps themselves are coated with the appropriate colour) before it is combined into one beam of integrated light. This method offers the advantage of a greater light output and the possibility of varying the voltage supply to each light source independently but it requires more careful alignment of each lamp to a standard colour temperature and increases the risk of lamp failure during a run threefold.

1

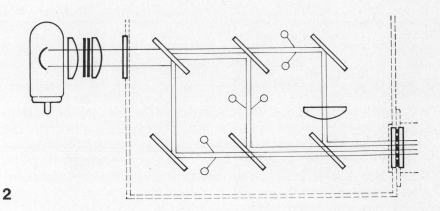

2

3

1 Simple lamphouse.
2 Colour additive lamphouse. The light from a single printing lamp is split into red, green and blue colour beams by selectively reflecting and transmitting dichroic mirrors.
3 Frame selector for choosing the length of an effect.

Basic effects

The step-printing facility and the ability to control the light source are the basic requirements of a printer and already, with only this basic equipment, a number of optical effects become possible. Interpositives and fine grain positives are usually made by the laboratory and printed on contact step-printers of this type. This reduces the risk of damage to the negative in transportation to and from the laboratory. This material is then used to produce duplicate negatives on the printer incorporating the desired special effect.

The preparation

Before printing can begin, the positive stock must be prepared correctly. A sync mark is scratched or punched at the head of the roll, a safe distance from the section which will be printed, to allow for lacing up. This sync mark normally matches an equivalent sync mark on the work print which also has the required optical effects marked up in wax pencil. The framelines on the leader of the work print must be indicated clearly to enable the correct positioning of the negative in the printer gate. The sync mark on the work print is the zero point from which precise footages of the start and end of all the optical effects are measured on a synchroniser.

When more than one positive element is to be printed from the same section of negative, then each has to be synced up to the zero frame. An A and B roll approach as used in negative cutting (*see* page 46) is often sufficient but, on occasions, each element has to be made up as a separate roll. After preparation, the material to be printed should be cleaned carefully by gently winding it through an antistatic cloth dampened with a cleaning solvent. Alternatively, and better, the film can be treated in an ultrasonic cleaning machine, a service which most laboratories offer to customers.

Fades

Most printer cameras are fitted with a variable rotary shutter which can be closed down from the fully open position (usually 170° or 180°) to the fully closed one. By progressively closing down the shutter opening a fade-out is accomplished. Repeating the process in reverse produces a fade-in.

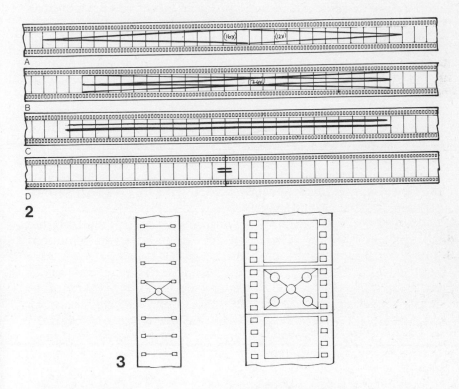

1 Synchroniser used for checking the guide copy and the assembly of duplicating material.
2 Guide copy markings. A Fade in (16 frames), fade out (12 frames). B A mix or dissolve (24 frames). C Double exposure. D Cancelled cut.
3 16 mm and 35 mm sync marks. Stock for bipack filming must be clearly marked so that all the components run through the camera exactly in sync.

Dissolves (mixes)

To produce the effect of one scene dissolving into another, it is necessary to close the shutter down progressively on the outgoing scene, wind back to the sync mark (zero), load the next scene and run the film down, with the shutter still closed, to the precise frame where the fade-out began on scene one; printing is then resumed and the shutter is opened progressively over the same number of frames from the fully closed to the fully open position. The curve followed by the *dissolve in* operation has to match the curve followed by the *dissolve out*, so that there is no appreciable change in print density at the point of dissolve. Overlaying a straight-forward fade-out and a fade-in does not produce a good mix (Fig. 2.X). The operation of the shutter can be manual or automatic where such a device is fitted to the camera. Automatic mix/fade units provide a choice of dissolve lengths of 8, 12, 16, 24, 32, 48, 64, 96, 128 frames.

Double exposure

The most critical factor with double exposures is the density of the negative. If the optimum exposure for one scene is 100% and it is printed directly onto the negative, then the negative is fully exposed. Printing a second scene over the same piece of negative would give it twice the normal exposure (200%). Consequently, the correct way to obtain a double exposure, that is where the balance between the two scenes is 50:50 is to cut down the printing light by one f stop. Each scene thereby contributes 50% of the exposure to the negative with the result that the negative receives its normal full exposure (100%).

The balance between the two scenes to be double exposed does not always have to be 50:50. However the total amount reaching the negative must always add up to 100% to maintain normal exposure.

Carefully matched scenes with large areas of black can be printed directly as overlays, as long as there is no substantial overlap of the exposed areas. In this case the two scenes could both be printed at full exposure.

Scenes representing average to dark tonal values are more suitable for double exposure than those with large bright areas. However, it is well worth remembering that in the negative form these light areas appear dark and it may be better to work with the CRIs of these scenes instead of interpositives. When the double exposure is to be introduced some way into a continuous scene and during the double exposure both scenes have equal prominence, then the following procedure should be adopted: Scene A is printed

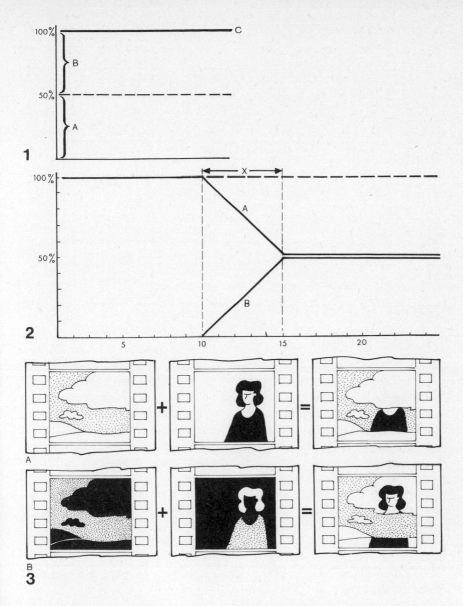

1 The negative can be given a normal full exposure (*C*) by two separate exposures at 50% of the norm (*A* and *B*).

2 Graphic representation of a double exposure introduced by a mix. Exposure on scene *A* is altered by means of a mix from full exposure to 50% (or one *f* stop less) over an exact number of frames (*X*). Mix out fully on normal exposure and then mix in over the same area at one *f* stop less exposure. Scene *B* is mixed in over the same area, also from zero, at one *f* stop below normal exposure.

3 *A* Scenes with large areas of white are not suitable for double exposure as positive images. On the other hand a double exposure of the same scenes in the negative form is very successful (*B*).

normally at full exposure down to the point where scene B is to be printed over it. The introduction of scene B can be as a straightforward cut, although in most cases a mix (dissolve) works better as an introduction to the double exposure. At the start of the double exposure, mix-out on scene A over a specified number of frames; the negative is wound back to the start of the mix-out. The mix-in starts again with the same scene in the camera (A), but this time the printing light is cut down by one f stop. Scene A is then printed for as long as required. Scene B is loaded into the printer for the second pass and synchronised to the same zero frame. At the same point where the mix was done on roll A, a mix-in on roll B is introduced lasting the same number of frames. The printer light is also set at one f stop below the normal exposure, and the printing continues after the mix-in is completed. The same procedure in reverse applies when one of the double exposed scenes is to disappear leaving the other to continue at full exposure.

Superimpositions

White titles prepared on high-contrast stock can be superimposed over a scene in two passes of the printer. The titles are usually overexposed by up to one f stop during the overlay pass so that they burn-in on the negative. Inevitably, in contact printing, even in the case of static titles, high-contrast positives have to be made running the full length of the superimposition. This is particularly useful when there is movement in the titles, or when they are animated (*see* page 91).

Coloured superimpositions are not possible in this way because an overexposed colour title would be black on the negative (and consequently white in the final positive). The colour of correctly exposed titles would mix with the colours in the background. producing yet different colours at those points. In those cases where there are large black or grey areas in the frame, coloured titles can be overlaid without a lot of difficulty. The same high-contrast black-and-white positive can be used for this procedure and the colour is produced by the appropriate filtration of the printing light.

When working with CRI materials, black titles can be overlaid in contact printing. The same high-contrast positive of the white title is printed over a CRI, resulting in a white image in the title area due to reversal processing. The final print made from that CRI will have black titles. However, the reversal in geometry must be borne in mind.

64

Solarisation

A contact step-printed CRI from the original negative and a contact step-printed interpositive from the same original are the two elements required to produce a solarisation effect. The interpositive and the CRI are printed in two successive passes of the printer onto the same negative (intermediate stock). The exposure balance between the two elements has to be determined by making a series of test runs, when one element is held at a chosen exposure and the exposure on the second element is progressively altered over a selected range and on every frame. The procedure is repeated again over the next section, which has a variation in the exposure of the first element, and so on until the first element has been fully covered by the whole range of the step wedge exposure tests. This 'wedging' can also include a series of progressive colour changes to produce the best results.

Solarisation of the entire shot is not as effective as when the shot starts normally and the solarisation is introduced at some later point. The procedure here is much the same as in the case of the double exposure. Alternatively, the entire shot can be solarised and the new negative cut as A and B rolls with the original negative, using a dissolve to link the two scenes in the final printing stage.

Black-and-white solarisation is also very effective and is produced in much the same way as colour solarisation, using black-and-white materials. It is also possible to use a black-and-white element in addition to the colour ones, or instead of one of them.

Colour tinting

A high-contrast step-printed positive, and a high-contrast step-printed negative can be made from the original negative which can be either black-and-white or colour. The negative and positive images are then printed through colour separation filters onto colour negative stock in two successive passes. Because the high-contrast stock registers tonal values in extremes of black-and-white, the result is a clear separation between dark and light areas in the scenes which are now represented on the negative by a primary colour. Because of a tendency for the high-contrast stock to pull towards tonal extremes and break up any grey areas, the final marry-up shows a third colour – the result of the mixing of two primary colours in areas where they overlap. When red and green are used as the primary colours a yellow outline emerges between the red and green shapes within the scene, giving it a very surrealistic feel.

The easiest way to obtain a pair of high-contrast positives and

negatives is to contact print one from the original negative and the other from a positive print made from that negative. The resulting reversal of geometry can be corrected by printing the high-contrast negative cel-to-emulsion in the final marry-up since the image is composed only of black-and-white shapes and not fine detail, which would make the loss of sharpness much more noticeable. It is also possible to have the high-contrast stock processed as reversal, in which case the geometry is not changed. Alternatively, the two high-contrast elements can be prepared on an optical printer (*see* page 93).

The tinting procedure described can be used to give further distortion of colour following solarisation. Positive and negative high-contrast records can be made from the interpositive and the CRI already prepared for solarisation. Two printing generations would restore correct geometry, although this is not essential as both high-contrasts can be printed cel-to-emulsion. However, two printing generations would produce, in this case, a greater separation of tones between the black-and-white areas of the scene, enhancing the effect.

Colour separation

Black-and-white panchromatic separation positives made from an original colour negative can be married up onto intermediate stock to produce a duplicate negative. Each positive colour separation master is printed through its appropriate colour separation filter (blue, red or green) (*see* page 00). However, if the marry-up is done through the 'wrong' filters deliberately, some very interesting colour distortions can result. It is possible to obtain negative colours in a scene which still remains positive. A further development of this technique is to make high-contrast copies from the black-and-white separation positives and use them for the marry-up instead of, or in addition to, the normal procedure. The combinations in this area are limitless.

Density of a normally duplicated scene can be increased if a black-and-white panchromatic positive of the same scene is run as an additional pass through the printer (*see* page 69). The final marry-up can also be done on standard negative colour stock, EC 5247.

Desaturating the colour (prefogging)
Prefogging the negative is an approach which is used extensively in conventional filming to desaturate colours and obtain an overall

1

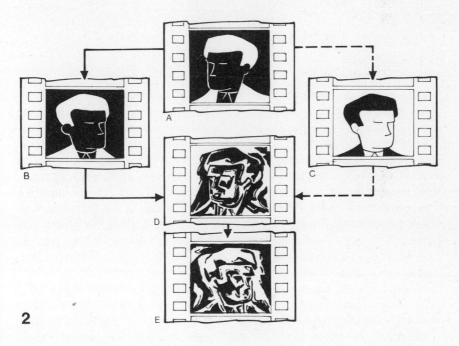

2

1 White high contrast title (*B*) superimposed over interpositive (*A*) will appear white in the final composite (*C*). The same white high contrast title (*E*) superimposed over a negative scene (*D*), printed onto CRI stock produces black titles in the final composite (*F*).
2 Solarisation. *A* Original negative. *B* CRI print. *C* Interpositive print. *D* Composite negative (solarised). *E* Composite positive.

reduction in contrast. This is done by exposing the entire roll of raw stock to a clear light either before or after actually photographing a scene, or during the take by means of a two way mirror acting as a beamsplitter to combine the lens image with a fogging light in a specially built lamphouse above the camera. The extent of the fogging determines the extent of the colour desaturation. Fogging affects the shadow areas more than the highlights, therefore blacks, or clear areas of the negative, are light struck and the appearance is of a reduction in overall contrast. In addition there is an apparent increase in sensitivity of the film stock because details in dark areas become more noticeable. The same procedure can be used in contact step-printing with the added advantage that the extent of fogging can be varied during the take if required. Total desaturation of colour is not possible with this method; when the fogging is increased beyond a certain level the image quality suffers. Coloured light can also be used in prefogging to add an overall hue to a particular scene.

From colour to black-and-white

It is possible to wash the colour from a scene so that it gradually becomes black-and-white, without any appreciable change in image quality. A colour interpositive and a black-and-white panchromatic fine-grain positive are contact step-printed from the original colour negative. These are then contact printed in two successive passes on to the same intermediate colour negative in the straightforward A and B roll procedure and linked by a long dissolve from one to the other. To make things more interesting a high-contrast positive from the original negative can be used to follow the black-and-white fine-grain positive and also linked with it by a dissolve. In this way a scene with full colour can appear to change gradually to a bleak black-and-white which, in turn, is replaced by harsh high-contrast images, as the scene unfolds.

Another approach is not to remove colour altogether, so that the picture has the appearance of a black-and-white photograph which has been hand-painted. This is achieved by printing the colour interpositive and black-and-white fine-grain positive as a double exposure. The exact ratio of exposure between the two elements will determine the extent to which colour will be present in the final scene. Coupled with sectional masking (or wiping) it is possible to have parts of the same scene in full colour gradually (or sharply) merging with the rest of the scene which is in black-and-white.

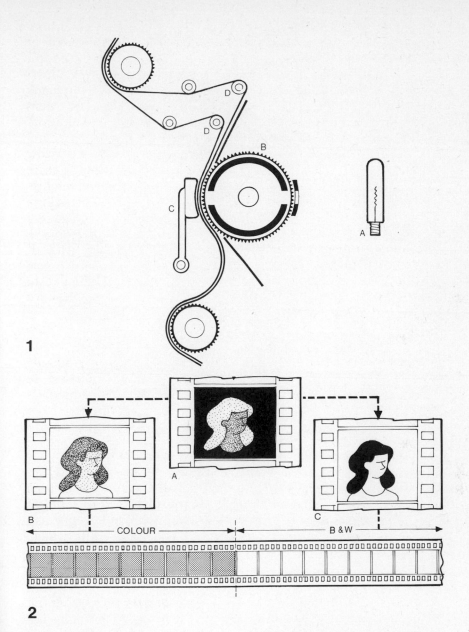

1 Continuous rotary contact printer. *A* Light source. *B* Rotating sprockets. *C* Polished steel pressure shoe. *D* Tension rollers.

2 *A* Original colour negative. *B* Colour interpositive. *C* Black-and-white panchromatic positive. *D* Colour negative stock onto which the scene is copied from the colour interpositive up to a specific point and then the printing is continued from the black-and-white positive. Alternatively, a mix can soften the change from colour to black-and-white.

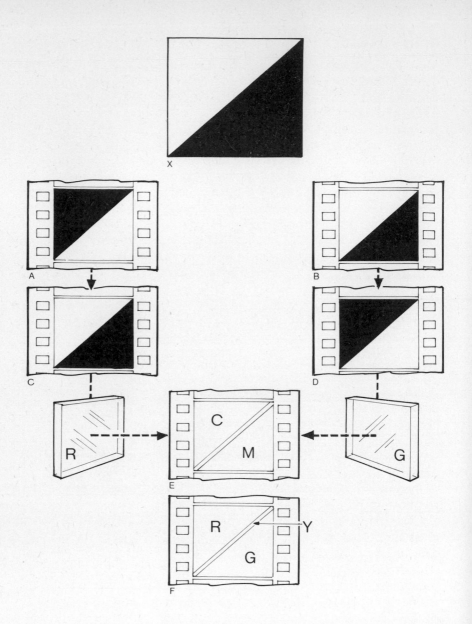

Colour tinting.
X Original scene. *A* Colour or black-and-white negative. *B* Colour or black-and-white positive. *C* High contrast print from negative (positive image). *D* High contrast print from positive (negative image). *R* Red filter. *G* Green filter. *E* Colour intermediate stock (composite negative). *F* Composite positive. White areas in the original scene appear red and black areas appear green. Inbetween overlap area is yellow.

70

Split screening

Most cameras designed for optical work have a variable masking device built into the camera body. It consists of two pairs of blades running horizontally and vertically in relation to the camera gate. Each blade can be manipulated independently. This facilitates, for example, splitting the frame area into two halves along the central vertical line. One blade is placed in position to mask off one half of the frame. During the printing procedure the printing light reaches the film in the gate only in the area which is not masked so that only that part of the positive which is being printed will be registered on the composite negative. On the second run the opposite mask is used. It is brought into contact with the first one to ensure correct alignment before it is removed to allow the printing light to reach the other half of the frame. The image from this half of a different scene is transferred alongside the image from the opposite half of the first scene, giving a split-screen effect. Naturally the split lines do not have to be limited to the centre lines and the frame can be divided into three or four segments if necessary.

Glass matting

As the camera on a basic printer is set on a horizontal bed and is capable of taking conventional lenses, it can also be used, in certain circumstances, for direct photography. Alternatively, a normal camera unit fitted with bipack magazines and a stop-motion motor could perform the same task (as indeed it could perform all of the work mentioned so far).

By removing the lamphouse in the printer, the camera lens is able to photograph objects placed in front of it.

Clear paper is stuck evenly to the surface of a large piece of glass supported in a rigid frame and placed in front of the printer. The interpositive of a scene, which needs to have a part of the background altered or extended, is projected onto the white paper. An artist prepares a painting in the appropriate areas of frame, carefully matching the perspective and colour of the rest of the scene. When the painting is completed the paper is cut along predetermined lines where a join is least likely to be noticed, normally following the shape of some geometric object in the picture. Light reflected from a white board behind the glass can now reach the lens through the clear section of the glass, while in the painted areas it is masked off. It is this light which 'prints' the interpositive of the 'live' scene which is run in bipack with the raw stock. On the second pass the interpositive is removed, the painting is

lit from the front and black velvet is placed behind the clear area of the glass. The final composite shows a perfect marry-up of the real section of the set, including action, together with the painted section added later. This is particularly useful when actors are required to appear very small because only parts of the set in the immediate action area need to be built.

This same set-up can be used for marrying-up matte paintings with 'live' scenes on the original negative without going through a duplicating stage, as described in Chapter I (page 16). Apart from being first generation, this approach has the advantage that it is easier to match colours because the photography does not involve duplicating stocks.

It is possible to use travelling mattes with this type of set-up, particularly if the matting area is over the painted area. The matte can be run in bipack with the raw stock during the photography

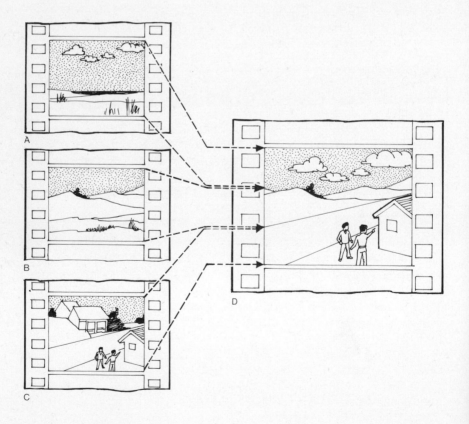

Composite *D* is made up from sectional printing of scenes *A*, *B* and *C*.

of the painting, which is normally done on the second run. On a third run the counter matte can be used so that the additional element can be photographed directly. Alternatively, a self-matting positive can be printed in bipack.

In certain circumstances a travelling matte can be used, which moves across both painted and printed areas of the frame. The travelling matte must be run in the printing gate during both passes – inevitably this means that three strips of film have to be run through the gate during the printing of the interpositive. The

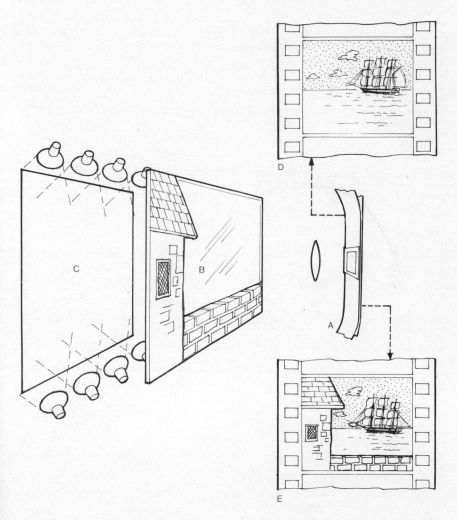

A Step printer. *B* Glass painting. *C* White board. *D* Interpositive scene. *E* Composite.

high-contrast (travelling matte) stock is added on the outside of the normal pack of interpositive and raw stock. When the second pass is made to photograph the matte painting, it is advisable to run a piece of clear stock in between the travelling matte and the raw stock so that the travelling matte image remains unaltered. The self-matting positive or the additional photographed element can then be added in the normal way.

Naturally tripack operation requires an extra feed and take-up facility. This can be done easily on some printers which are equipped with outside 'open reel' take-ups for duplicating stock and a standard magazine for raw stock. The raw stock magazine can be replaced with a bipack one to enable a tripack operation. Using this type of set-up, a composite can be made up of several 'live' elements as well as a matte painting, or it may not involve a matte painting at all. A sky shot in one location can be added to the mountain range shot in another and a third element can represent the foreground. By masking off certain areas on the glass a particular section of the interpositive is printed; a counter mask on the glass is then cut-joined to the first before it is removed, to ensure perfect line up, and then the second element can be printed, etc.

Split screening with sharp-edged outlines, overlays and many other effects are possible in this way.

Camera plus projector head

Although there is a great deal of optical work that can be done with the use of the camera head and a lamphouse alone, there are also a lot of limitations. When a projector head is added to the camera this becomes a basic optical step-printer.

The camera. This is mounted on a horizontal bench of very rigid construction. The camera body is moved along the base independently of the lens, which is connected to it by extension bellows. The most popular gate in optical printer cameras is a fixed pin Bell and Howell type – the clapper gate. The gate and the transport mechanism are usually interchangeable between 35mm and 16mm, and sometimes for Super 8 also. An automatic *fade/ dissolve* mechanism and bipack magazines are usually standard features. In most cases the camera can be pivoted around its optical axis to give tilts of between 20° and 35°. Variable speed stop-motion motors are controlled from a console, which is usually built into the base of the printer.

The lens. This is mounted on an independent carriage and connected to the projector body by means of extension bellows. The lens mount enables the lens to be moved vertically and horizon-

74

tally as well as towards or away from the camera body. Lenses are interchangeable. At the normal position, the lens photographs the full image in the projector gate at a same-size ratio (1:1). To reduce the photographed image the camera is moved away from the projector on the optical axis. To make selective enlargements of the same image, the camera is moved closer to the projector gate. The lens mount is moved independently to keep the image in focus. Some projectors can track in or out with automatic focusing. The considerable changes in exposure necessary at different reproduction ratios can be compensated for by an *automatic iris*.

The projector body. This is mounted on the same bench as the camera; the gate mechanism is of the same type as used in the camera and is often interchangeable. The gate can take two strips of film in contact, in the same way as the camera, and two sets of take-ups are provided for this purpose. These are of the open reel type since the film stock used in the projector is already processed.

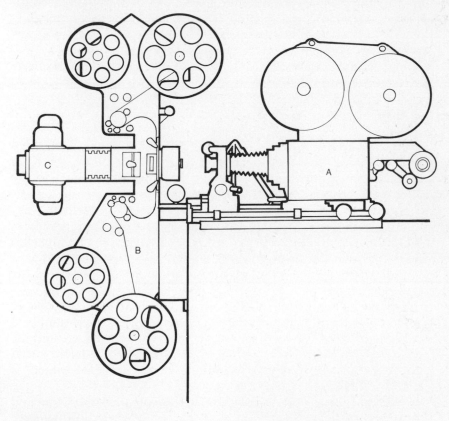

Optical printer.
A Camera head. *B* Projector head with bipack facility. *C* Lamphouse (standard).

The variable speed motor which drives the projector assembly is controlled from the console and can be interlocked with the camera motor, both in the forward or reverse mode. The lamphouse includes condenser lenses which are designed to illuminate the projector gate evenly. Colour is corrected by filtration on those printers not fitted with a colour additive lamphouse. A *filter disc* with 24 filter slots which change automatically with each frame is a useful aid for colour correction tests.

Liquid gate

There is not much that can be done about serious scratches on the emulsion side of a film, but cel (or base) scratches can be minimised by liquid gate printing. The light rays passing through the film base are refracted differently where it is scratched and this makes the scratches very noticeable as black lines. By immersing the entire film in a liquid whose refraction index matches that of the film base cel, the scratches become invisible. The liquid fills in the scratch and the light rays are refracted uniformly over the entire picture area. Apart from eliminating the cel scratches, liquid gate printing produces cleaner results. The gate is built around the basic shuttle gate (clapper gate) with the picture area (or aperture) enclosed by glass. Liquid is circulated through this watertight compartment in a recycling operation.

Focus pull

Once the film being printed is separated from the camera gate, as in optical printers, then a lot of new possibilities open up which are impossible with contact printing. One of these is to deliberately defocus a scene, or bring it into sharp focus at a required moment. This can be done either on the composite scene or only on title superimposition during a separate run. A useful effect here is to combine a focus pull with a fade-in or fade-out, on superimposed lettering. A focus pull and a dissolve from one scene to another can also be very effective. In either case it is important to establish the focus pull by making it last a few frames longer than the fade or dissolve.

Freeze frame

For normal printing the camera and projector are interlocked so that after the camera has taken one frame the film in the projector gate is advanced to the next frame. By disconnecting the projector

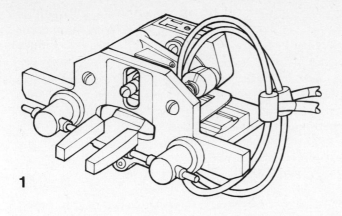

1

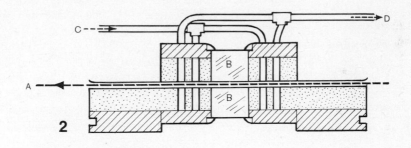

2

3

1 Liquid gate.
2 Cross section of liquid gate. *A* Dry film exits. *B* Glass. *C* Liquid from filter. *D* Vacuum to reservoir.
3 Liquid gate support system.

unit from the interlock system, the same frame of film can be held in the projector gate while the camera unit continues to shoot. This can be done with any frame, in any sequence and for as long as required. On projection, the action appears to freeze at the point where the interlock system was disconnected. The action can be made to continue as normal after the freeze by interlocking the projector and camera unit again. This facility means that a static title superimposition need only be one frame in length, although in practice about 10 frames are shot for this purpose. These are known as 'slip-negs'.

Skip framing

Since the projector unit can run independently from the camera unit and both of them are operated by stop-motion motors, it is possible to miss out any frame in the film being duplicated. By not photographing every other frame of the original film, the action on the print appears twice as fast. On the other hand, by printing every frame twice the action is 'stretched'. This is useful when a scene shot at 16 frames per sec has to be stretched for projection at 24 frames per sec – in such a case every third frame is printed twice. Any combination of skip framing is possible at regular or random intervals. A freeze-frame effect can be enhanced if, a few frames earlier, the frames are 'stretched' progressively.

Reverse printing

The projector unit can run in reverse while the camera unit continues to shoot forwards. This makes the action within the scene appear to move backwards. This is a useful effect and can be introduced in the middle of a scene running forwards when the action is suddenly reversed and then continues forwards again. When combined with skip and freeze framing, reverse printing can be very effective.

To extend a scene it is best to print several static frames backwards and forwards where possible, instead of freezing one frame only, as this avoids a grainy effect.

Rippling or strobing effect

Scenes of high contrast on black backgrounds and using rim lighting (contra-lighting) are most suitable for this type of effect. The scene is printed as normal once and on the second run it is printed again with a three to four frame delay, depending on the

1

2

1 Marking up freeze frame on the cutting copy guide. It is also wise to put down the exact position to be frozen in terms of edge numbers, eg AY 0015+3.
2 Skip framing and reverse printing. *A* Original scene in projector gate. *B* Raw stock in camera gate.

speed of the action. Further passes through the camera, with equal delays, produce additional images of the same action, which then appear as a ripple trailing the original image. For example, if a dancer is seen dancing in one half of the frame for part of the scene and then moves over to the other half of the frame, it is possible to print a freeze frame of the dancer from the end section of the shot and hold it on the screen until the normal action of the dancer moves across frame and merges with the freeze frame, when normal action can resume.

A B

Subject shot against a black background and lit from the side so that only the outline of the figure is clearly visible. The effect of the progressive movement from A to B appears as a ripple movement.

Double exposure

A conventional double exposure involving two separate runs through the camera can be varied with the introduction of various

Scenes A and B are held in contact as they are copied optically to produce a double exposure C.

80

optical effects on one or the other (or even both) of the scenes being duplicated. Skip frame, freeze frame, focus pull, reverse printing etc, can all be added to the existing facilities.

With the bipack facility on the printer head, it is possible to produce the effect of a double exposure by running the two scenes in contact with one another in the printer and copying them simultaneously. Inevitably, some scenes lend themselves better to this kind of treatment than others. There is still the choice of doing the entire operation as interpos/interneg or as CRI – both of which methods produce a different emphasis between the two scenes being double exposed.

Geometry reversal

It is often necessary to 'flop' the image laterally, either to get around a difficult cutting problem, or simply to obtain a mirror image of a particular scene. Another reason is that the geometry of one of the elements to be used in the production of a specific optical effect may not match the others, in which case it is simply flopped in the projector unit. The film can be laced up in the projector, with the emulsion either to the lens or to the light as required.

Tilting

The optical printer camera is usually mounted to facilitate up to 35° of tilt around the lens axis. This is useful for correcting any levelling errors in the original photography and can also be used to produce a rocking motion.

Reframing

Accidental and unwanted intrusion in a frame can be removed by selective enlargement of the picture. Reframing is also necessary when there is a change in the aspect ratio. The image can be reduced in the frame to form one element of a split-screen combination with other elements. Anamorphic material can be 'unsqueezed' and printed onto Academy standards or 1.85:1 aspect ratio with appropriate reframing, and vice versa.

Changing the formats

As both camera and projector have interchangeable 35mm and 16mm movements it is possible to make reductions or blow-ups from one format to the other. This also makes it possible to use materials on one format while shooting the composite on the other.

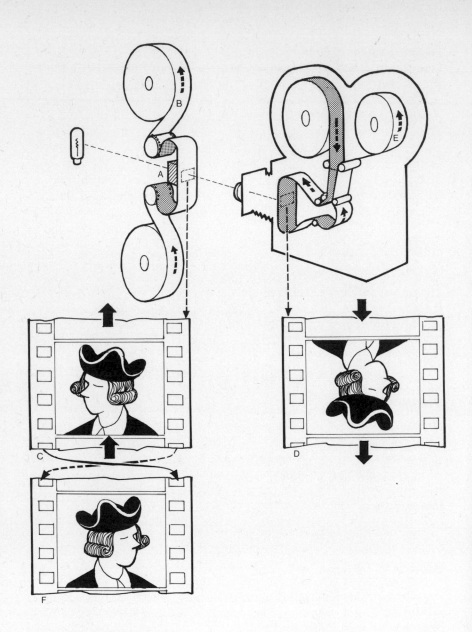

A Projector gate.
B Direction of film travel (normal).
C Image in projector gate.
D Same image in camera gate.
E Direction of raw stock travel through camera.
F Reversed geometry.

Moves within the picture

Zooming and panning within the picture area is possible to a limited degree only, due to the problems of grain and lack of definition when enlargements exceed a 2:1 ratio in 35mm. When shooting on 16mm from a 35mm original, then enlargements up to a ratio of 4:1 produce acceptable quality. An optical composite shot consisting of several elements all shot with a static camera can be given an extra feeling of realism by a zoom or pan within the picture. Wherever possible a larger format should be used for the production of the composite original.

Split screening made easier

In the earlier example of split screening by contact printing, each element had to have the image in the correct position, i.e. corresponding to the position of that image in the composite. By using a projector head, the images of the various elements can be positioned anywhere within the frame; they can be reduced or enlarged to fit a particular shape as required. This makes it a lot easier to plan and shoot the various elements.

Distortions

Because of the physical separation between the projector and the camera it is possible to insert distorting materials, image fragmenters and prismatic attachments which can rotate the image through 360°, beyond the limitations of the camera tilt. The image can also be copied vertically with the aid of the same prism, turning the image through 90°. Naturally, this means that the original has to be enlarged with the resultant increase in graininess.

Bipack matting

A high-contrast print of a graphic shape which can be static or continually changing its shape, is one type of travelling matte. When it is laced up in the projector unit in contact with the positive image to be printed, the high-contrast matte obscures the light from those areas of the frame which are black on the matte and allows the areas opposite the clear sections of the matte to be photographed. As the shape of the matte changes during the printing operation, the areas of the duplicating stock which are exposed change correspondingly. On the second run through the camera another positive image is laced up in the projector unit with the

counter matte – which is the negative image of the first matte.

The second positive image now registers in those areas which were left unexposed during the first run. Alternatively, the counter matte can be run alone and the projector light filtered to produce the effect of a coloured shape intersecting the scene or obscuring it altogether. Very interesting wipe effects can be produced in this way where one scene is wiped off by another, or simply by a coloured shape which can then break up to introduce the next scene. Objects can be inlayed into a background scene if a suitable matte and counter matte can be produced. The background scene is first printed in contact with a male matte of the object to be inlaid. On the second run the interpos of the object itself is printed in contact with the female (counter) matte.

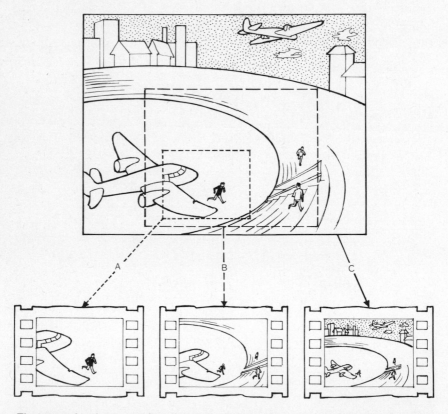

The composite picture consists of three live elements and a matte painting of the buildings on the top left of the picture. *A* Close up of the aeroplane's nose as it enters frame. *B* Pull out to reveal the location, as the men jump out. *C* Full view of scene as second aeroplane thunders overhead.

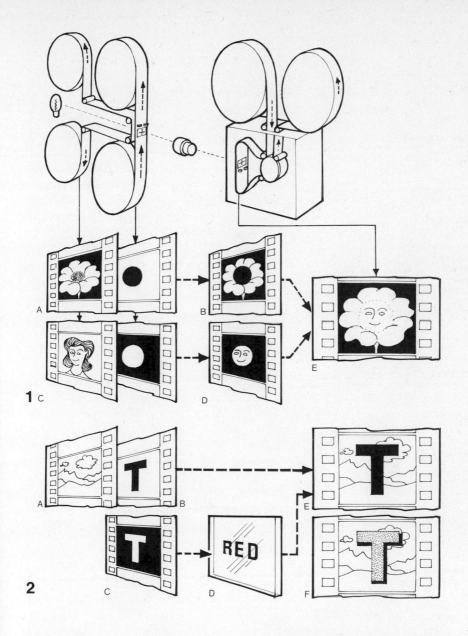

1 Scene *A* and male matte are printed in contact to produce image *B*. Scene *C* is then printed on the same negative in contact with female matte, to produce image *D*. *E* is the final composite.

2 Colour titling and drop shadows. Background *A* is printed in contact with high contrast negative of title (*B*) on the first pass. Then high contrast positive of same title (*C*) is printed through an appropriate colour filter to produce a composite (*E*). By reducing the image and moving it to one side for the second pass a drop shadow effect is achieved (*F*).

Coloured lettering

Coloured lettering can be inlayed into a colour scene, without the danger of background colours mixing with the colour of the inlay, by running a high-contrast print of the negative image of the lettering in contact with the background scene. The black of the lettering prevents exposure of the frame in those areas, while the rest of the scene is copied normally. On the second run through the camera the second high-contrast print, with the positive image of the lettering, is laced in the projector on its own. Because of the dense black background only the clear white letters are reproduced. By tinting the light source these letters can be recorded on the unexposed areas of the frame in any desired colour.

Drop-shadow titling

Neither white nor coloured lettering stands out very clearly on certain types of backgrounds. In order to get over this problem a drop-shadow technique is often used. The procedure for the first run through the camera is the same as for normal colour inlays; the high-contrast negative of the title is run in contact with the interpositive of the scene. On the second run the positive image of the title is reduced slightly and moved off-centre. The inlayed image still falls inside the unexposed area of frame, but as that area is slightly larger it has the appearance of a shadow whose outline corresponds to the shape of the letters.

Camera plus two projector heads

More complex optical effects can be done in one pass through the camera when an optical printer is fitted with two projector heads. A matte and the background are laced up in contact in one projector and the scene to be inlayed and the counter matte are laced up in the other projector head. The projectors are mounted at 90° to each other. The camera can photograph the images in the gates of both projectors by means of a beam-splitter prism. The two images are seen as a composite and any misalignment or mismatching of colour and densities can be detected more easily than in the case of double passes.

The second projector head has its own lamphouse and a separate drive motor which can be run independently or in interlock with either the first projector or the camera, or both.

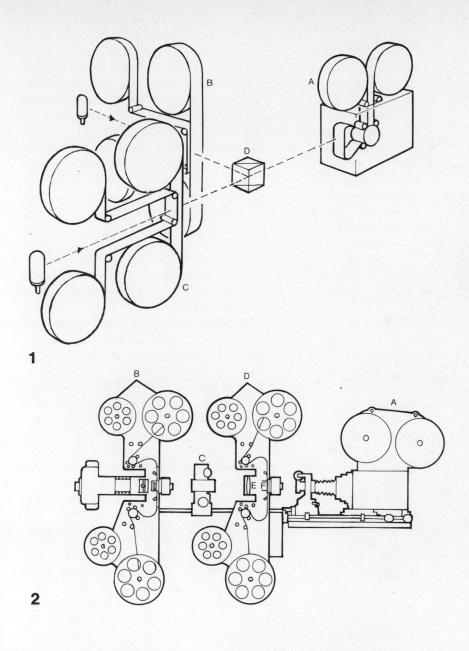

1 Optical printer with two projector heads set at 90° to each other. *A* Camera. *B* Projector head set at 90° to camera lens axis with own light source. *C* Second projector head set in line with the camera, with own light source. *D* Beamsplitter prism.

2 Optical printer with two 'in-line' projector heads. *A* Camera. *B* Projector head with lamphouse. *C* Projector lens. *D* Second projector head. *E* Aerial image field lens. *F* Projector gate where the image from projector *B* is focused by lens *C*.

Aerial image

The second projector does not always have to be at 90° to the first, but can be in line with it, tandem fashion. The projector farthest away from the camera is the only one fitted with a lamp-house. In addition, this projector has a lens so that the image from its gate can be focused on the gate of the projector in front of it. This is done with the aid of a field lens placed close to the gate of the second projector. This image is known as an aerial image because it cannot be seen normally, unless some form of diffusing material is placed at the point of focus which, in this case, is the gate itself. Frosted film is a useful material for this purpose. However, the aerial image is seen perfectly through the camera viewfinder.

Because there is only one light source, the two projectors in tandem, using real and aerial images, cannot produce the same number of effects as two projectors set at 90° using the beamsplitter prism. On the other hand, they make it possible to run a high contrast film in the projector nearest to the camera and operate it quite independently of the background, which is loaded in the other projector. Colour inlays and drop shadows of static lettering can be done with only one frame in the gate of the aerial image projector. Alternatively, a graphic wipe can be stretched or contracted without affecting the printing of the background image; the background image itself can be freeze-framed, printed forward or reversed with the inlay mask following an entirely different pattern. Admittedly, a second run is necessary for the marry-up to be completed. However, the freedom of movement and the facility for repositioning one image in relation to the other outweigh most of the disadvantages.

Using multihead optical printers

An interesting effect that can be done with this type of equipment is to produce a gradual change in a scene from freeze-frame to normal action, so that whilst part of the frame is still 'frozen' the rest of it is normal. Naturally, only a static shot could be used in this way until the freeze sequence is concluded. The background scene is loaded normally in the projector and the high contrast matte (carrying the wipe which will progressively obscure the frame) is loaded in the aerial image projector. During the printing the background remains frozen on a chosen frame as the second projector and camera run interlocked. After the picture has been entirely obscured by the high-contrast wipe, the camera is wound

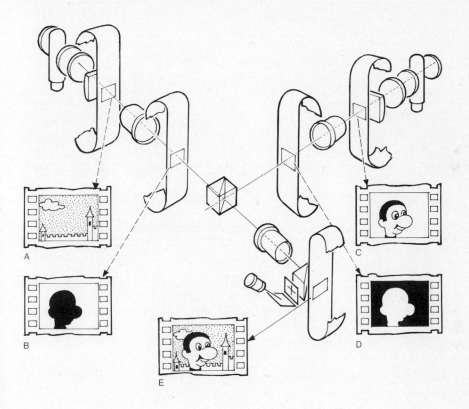

One pass marry-up with optical printer with four projector heads. *A* Background interpositive. *B* Male travelling matte (can be adjusted). *C* Foreground interpositive. *D* Female travelling matte (can be adjusted). *E* Composite.

back to the start and the counter matte of the wipe is loaded in the aerial image projector. On the second run both projectors are interlocked with the camera and the scene is printed for as long as required after the end of the wipe-in. The effect can be greatly enhanced if the wipe is prepared so that it animates in an irregular line, moving very slowly across the frame. As it is the same scene throughout, the only noticeable difference is in those elements of the scene which move. The choice of the scene, therefore, and the shape and direction of travel of the wipe are all important.

Camera plus three projector heads

A projector head set at 90° to the camera lens axis can be incorporated into a set-up comprising two 'in-line' projector heads. A self-matting positive can be carried by this extra projector head and the entire operation can be performed in one run through the camera. An additional advantage is that the composite scene can be viewed through the camera. However, when a counter matte has to be used there is no flexibility for adjustment because it has to be carried in bipack with the positive to which it relates.

Camera plus four projector heads

All the advantages of both in-line aerial image projectors and those set at 90° to each other are incorporated in an optical printer with four projector heads. Two pairs of in-line aerial image projectors are set at 90° to each other and their images combined by means of a prismatic beamsplitter. Two lamphouses provide illumination for two basic images in the outer projectors and the inner projectors can carry auxiliary masks or any other mattes that may need to be adjusted in some way. A colour inlay of a static title could be executed in one pass with a freeze frame of the positive and negative image of the title provided as a short clip on high-contrast stock. A travelling matte composite can be married-up in one pass.

5 Making travelling mattes

Hand-painted mattes

Making a graphic matte, an animated wipe and mattes of lettering
is relatively simple. It involves the preparation of black-and-white
artwork which is then photographed on a high-contrast stock.
The counter matte can then be made from this by additional
printing. These mattes can be made to follow the outlines of
certain fixed objects in the frame; following these natural lines
makes the matte line less noticeable and the composite looks more
convincing. In some cases hand-painted mattes can be prepared
for a moving object too, but this is more difficult and involves a
greater number of drawings. An interpositive from the original
negative is projected (rotoscoped) through the camera gate and the
outlines of the moving object are traced out by an artist. Regis-
tration is maintained by the use of animation punched cels which
are registered on a pegbar (*see* page 102). Effects such as falling
debris in the foreground of a live scene can be done in this way as
relatively few frames are involved. It is also possible to do space
backgrounds by this method, where only stars have to be elimin-
ated in the path of a spaceship.

Self-matting positives (black velvet)

Studio work photographed against deep black backgrounds,
such as black velvet, and exposed so that no background detail is
visible, make easy self-matting positives when the negative is
printed onto interpositive film, or shot directly on reversal stock.
It only requires a female matte of the same action before the marry-
up of the two elements can be done. The negative is then printed on

high-contrast stock, several times if necessary, until a good male matte is achieved. The interpositive from the original negative is, of course, self-matting.

White can also be used in the background instead of black to produce self-matting masters. The white of the background has to be lighter in tone than any part of the object so that it registers fully on the emulsion. A high-contrast print is made from this original negative to produce a male matte. In practice, it may need to be duplicated several times to achieve good overall contrast and density of the image. A CRI made from the original is used together with the CRI of the background scene for the marry-up. The CRI is, in fact, self-matting. To ensure a good density on the self-matting positive (or CRI), it is advisable to make a counter matte from the high-contrast matte and run the two together in bipack.

Neither of the above systems are really totally satisfactory for the production of travelling mattes for colour work generally, but both can work very well in certain specific situations where the subject does not lose too much by flat lighting.

Double pass system

This system relies on the travelling matte being photographed on a separate run through the camera. It exploits the principle of a self-matting positive but without the restrictions on lighting, as in the earlier example. Obviously this rules out any live action work, but models, geometric shapes and still cut-outs, lend themselves very well to this technique. The primary requisite is the ability to repeat an action with the greatest degree of accuracy. The equipment controlling the studio camera and the model or artwork must be designed with this function in mind. Animation stands are a good example of this type of machinery but they are not suitable for model work. Certain computer systems used on the rostrum cameras can perform this task automatically. They, or similar computer arrangements, can be used for model shooting as well, in conjunction with specially designed rigs. The model is photographed once against a black background on colour stock with normal lighting and with as much contrast in it as the scene requires. For the second pass, high-contrast stock is loaded in the camera, the object is painted white and illuminated evenly by diffuse, shadowless lighting. The action is then repeated exactly as for the first pass and a male high-contrast travelling matte is produced. In practice, models, such as spaceships, are mainly white so that flat lighting alone is sufficient to give a good matte. If the colour stock used in the first pass is reversal instead of neg-

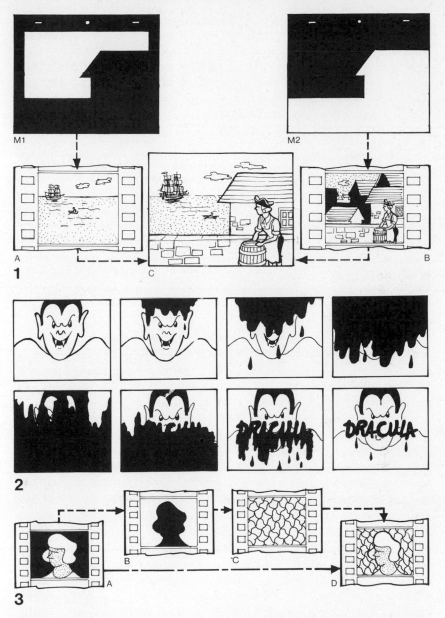

1 *M1* is a static hand-drawn matte through which scene *A* is printed. (*M1* is produced by rotoscoping scene *B*). *M2* is the counter matte which can be derived photographic-ally from *M1* or else both are cut simultaneously out of two pieces of black paper held in register by a registration pegbar. Scene *B* is printed through *M2* and *C* is the composite.
2 Animated travelling matte acting as a transition wipe between scenes and finally metamorphosing into a title.
3 *A* Self-matting positive (subject lit flatly). *B* High contrast matte. *C* Positive of back-ground action. *D* Composite.

ative then both the male matte and the self-matting positive are first generation; their geometry is compatible with each other although the images are flopped. There is nothing wrong with this as long as it is allowed for in the planning and one side of the model does not appear to be very different from the other. Any markings have to be done as mirror images on the actual spaceship, or whatever, so that they appear normal in the final composite. The marry-up can be done on an optical printer and the geometry corrected at that stage.

Shooting on colour negatives instead of colour reversal produces an incompatability of geometry between the positive image and the high-contrast matte which can be corrected in three ways:

1. By reversal processing of the high-contrast matte to produce a female matte which is then printed again to produce a male matte.
2. By duplicating the high-contrast matte twice in order to produce a male matte with optically reversed geometry.
3. By flopping the high-contrast matte in the optical printer for the marry-up.

The marry-up can also be done on CRI using the negative stock throughout. This requires the making of a high-contrast positive (female) matte optically so that the CRI of the subject can be printed through it. However, this stage can be eliminated altogether if the subject is filmed against a white background to produce a negative image on a black background which is also self-matting. The background must be black for the travelling matte filming and the model (subject) is painted white, as before.

It is not easy to evenly light a fairly large white area and filming against a white background always presents more problems than against black. However, fairly successful attempts have been made using a front-projection screen as the background onto which white light is projected. In this case the second pass on high-contrast stock is done with the projection light off, giving effectively a black background. However this is not as easy a solution to white background filming as it may at first appear (*see* Front projection).

Using colour backgrounds

Deep blue is the colour most commonly used as the background, although red can be equally effective. The reason for using a blue background is that after matting the colour out the absence of deep blue from the spectrum is less noticeable than the absence of red, particularly when the scene involves flesh tones. The 'blue

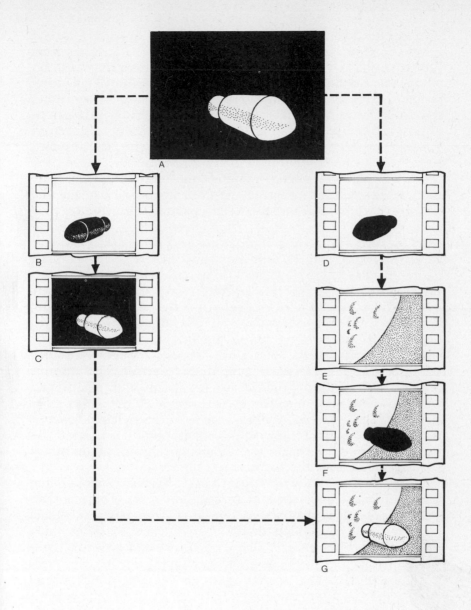

A Original scene. *B* Original negative. *C* Self-matting positive. *D* High contrast negative shot on a second pass after the rocket had been painted white (note incompatible geometry). *E* Background positive. *F* Background positive printed through high contrast matte *D*. *G* Final composite when self-matting positive is added.

backing' can be either painted on and lit evenly from the front, or it can be made from translucent material and transilluminated (lit from behind). The actor is placed in front of this background and illuminated normally by white light. In practice, a small amount of yellow is often added to the lights to help increase the separation from the blue of the background. The balance between the background and foreground can be checked by looking in turn through a colour-separation blue and then red filter before actual photography. When looking through the blue filter the balance between foreground and background should be equal. When looking through the red filter the background should appear totally black. Lighting adjustments should be made until this balance is struck. A master colour positive made from the original colour negative is printed onto black-and-white panchromatic stock, through a blue filter, to produce a *negative image on black background*. The same master positive is printed again through a red filter to produce a black-and-white *negative image on a clear background*, as the red filter absorbs the blue of the background resulting in no exposure in that area, giving a clear background. By printing this last matte onto a high-contrast stock we get a *positive image on black background*. Alternatively the extra printing involved can be eliminated by processing the exposed red matte as reversal. Thus, both a positive and a negative image are produced on a black background. These are printed onto the same piece of high-contrast stock, in succession, to produce a male matte. A female counter matte has to be made from the male matte to block out the blue background on the master colour positive during the final marry-up.

Alternatively, the black-and-white film record through a blue filter, which produces a negative image on a black background, can be processed as reversal, or copied again to produce a positive image on a clear background. By sandwiching this in bipack emulsion-to-emulsion with the red filtered record which also has a clear background but a negative image, and rephotographing it on high-contrast stock, a female matte is obtained.

Although much simpler than the other 'blue blacking' process this approach has the same drawbacks as most travelling matte systems. The necessity for many different generations in the production of the mattes results in unsteadiness of picture and a variation in matte sizes, producing a blue halo effect around the inlayed figure where the mismatch has occurred. Translucent objects, nets, loose hair, glass etc, tend to be either lost altogether or produce strange fringing problems. Naturally, as in the case of any colour used as a background, blue cannot be used in the clothing or costumes of the actors or props in the foreground. One

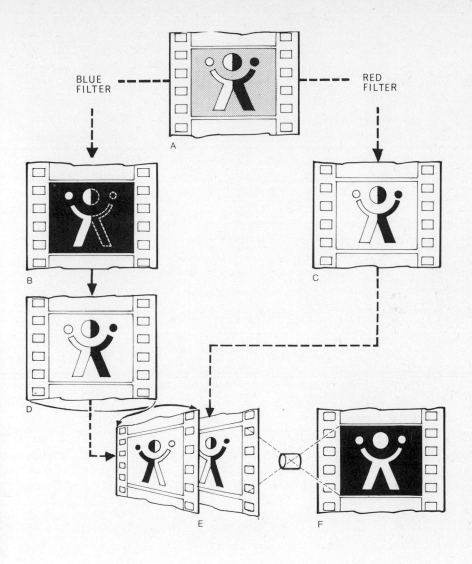

BLUE
FILTER

RED
FILTER

A

B

C

D

E

F

A Master positive. *B* Black-and-white panchromatic print through blue filter. *C* Black-and-white panchromatic print through red filter. *D* Duplicate of *B*. *E* Bipack 'sandwich' of *C* and *D*. *F* Full female matte.

of the problems which is not readily recognisable is that the blue backing itself acts as a giant light source, backlighting the subject and it often produces blue fringe lighting in the shadow areas of the subject.

Colour difference: 'blue screen' system

This is probably the most complex method for deriving travelling mattes but produces better results than the simple system described above. The photographic approach is basically the same. The actor is placed in front of a blue backing and lit conventionally by white light. Occasionally, a variation on this is used where a small amount of yellow filtration is added to the lights, which is later compensated for. Colour negative obtained this way is copied onto black-and-white panchromatic stock through the three colour separation filters: blue, red, green. This produces black backgrounds on the red and green separation positives and a clear background on the blue one. The key to this system is to produce a synthetic blue separation positive with the same density value as the original but with a black background, instead of clear. The first step is to make a 'colour difference' matte. This is, in effect, the density difference between the blue and green separation positives and is obtained by printing the original colour negative and the green separation positive in bipack.

A matte obtained this way is then printed in bipack with the green separation master. Further cover masks are normally also required before the marry-up can be done. This is a patented process.

Multifilm systems

Using special cameras with two identical movements set at 90° to each other, a matte can be shot at the same time as the original negative. The light from the lens is diverted to the two gates by a beamsplitter. There are three basic systems using this approach and they are known by the light source by which the matte image is produced: infra-red, ultraviolet and sodium vapour.

Infra-red process. One of the camera units is loaded with infra-red film, the other with colour film. Black nylon velvet is used as the background and is lit by normal incandescent lighting – however, only the invisible infra-red light is reflected by the black velvet. Alternatively, a translucent screen can be used, illuminated by a light source with an infra-red filter so that it is invisible to the naked eye. The subject in front of the screen is lit by normal white light from which the infra-red radiation is absorbed by dichroic

98

filters. Another dichroic filter in the beamsplitter ensures that all infra-red radiation from the background is directed to the infra-red film and that only visible light reaches the colour film loaded in the other gate. Since the infra-red radiation has a different focus plane from visible light the matte produced by this method has to

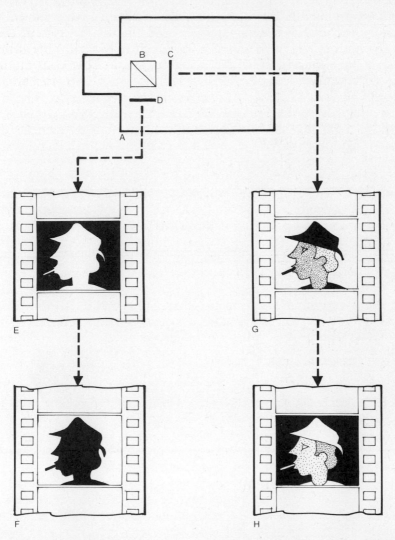

Multifilm travelling matte system. *A* Two strip camera with beamsplitter prism (*B*). *C* Film gate in line with lens axis. *D* Film gate at 90° to lens axis. *E* Original negative travelling matte. *F* High contrast positive print from *E* producing a male matte. *G* Colour negative. *H* Self-matting positive from colour negative (*G*) can be married with any prefilmed background with the help of the male matte (*F*).

be reduced optically before it can be used. The main advantage of this system is that any colour can be used in the foreground. This is a patented process.

Ultraviolet process. Fluorescent lamps are used to illuminate a translucent screen from behind, providing the necessary ultraviolet radiation for the background. Ultraviolet sensitive black-and-white stock is used to record the matte and the beamsplitter is coated with a Corning filter medium to reflect the ultraviolet radiation to it. An ultraviolet absorbing filter is placed over the lights to eliminate the unwanted radiation from the foreground action. As in the case of the infra-red process, the colour image is self-matting (in the positive mode) and a female matte (clear in the area of the subject and black in the surrounding area) is produced at the same time. The ultraviolet image, however, focuses closer than the infra-red, and the matte image is smaller than the image recorded by visible light and has to be optically enlarged. This is a patented process.

Sodium vapour process. This method produces a matte which is identical in image size to the colour record. It uses monochromatic yellow light produced by sodium vapour lamps. Normal incandescent lamps filtered with a didymium coating are used for the illumination of the foreground. In practice, additional blue filtration is needed to maintain the colour temperature of the foreground lights at 3200K. A monochromatic yellow filter in the beam-splitter and in front of the matte gate allows images to be recorded on black-and-white panchromatic stock while a didymium filter in front of the other camera gate, loaded with colour stock, ensures complete separation. This is a patented process.

6 The rostrum camera

Although originally developed as a means of shooting flat artwork animation, the rostrum camera has evolved into a formidable tool for the production of special optical effects.

The stand

The majority of animation stands are of rigid construction, consisting of a solid metal base and one or two vertical columns, depending on the design, which serve to move the camera up and down. The weight of the camera and the camera mount is counterbalanced by lead weights; in the case of the single column stand the counterweights are inside the column. This tracking movement is normally motorised but it can also be operated manually.

The table

This can be an ordinary table on which the artwork is placed for photography. On sophisticated stands the animation table forms part of an elaborate compound assembly which is capable of very intricate movements with an extremely high degree of accuracy. This is very important because all camera moves are, in fact, executed by moving the artwork while the camera remains in a fixed position. The camera can be positioned anywhere along the column, so that various field sizes can be photographed, or it can be tracked continuously through the shot [zooming].

Registering the artwork

The artwork is normally registered by means of pegs; two flat pegs with a circular one in between them form the basic unit. These can be either loose bars which are stuck to the animation table or they can be made up from individual pieces which are screwed into slots specially provided for them. These slots are on moving pegbars which are built into the animation table, so that their upper sides are flush with the table surface. There is a choice of two to four of these pegbars running in parallel and at predetermined distances above and below the table centre. The pegbars are controlled by calibrated wheels positioned along one side of the table. The pegs are fitted as and when required, and can be placed all the way along the bar in those cases where long panning cels (the celluloid sheets onto which the artwork is drawn) are used. It is important that the cels are punched with the same standard punch that corresponds with the dimensions of the pegs.

The cutout

The central area of the table is cut out and carries a piece of glass whose upper surface is flush with the table top. This is used for backlit artwork and transparencies.

The rotation

The animation table is mounted on a rotation ring and can be rotated through 360° by means of a calibrated control wheel and a gear linkage. Apart from enabling rotation during a take, this is also useful for positioning the table at any angle so that the travelling pegbars can be used to pan the artwork in any desired direction.

North/south movement

The animation table and the rotation unit are in turn mounted on a set of tracks which enable the entire unit to be moved in a north/south direction. This is done by means of a control wheel connected to a threaded shaft.

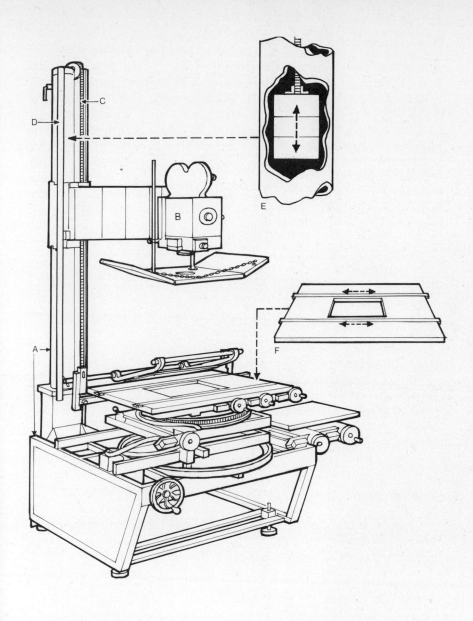

A Column and base. *B* Camera mount and camera. *C* Chain drive. *D* Follow-focus rack. *E* Counterweight inside column. *F* Animation table, moving pegbars are built into the animation table-top.

East/west movement

The basic compound is completed with the addition of the east/west movement. The entire assembly is placed on another set of tracks and moved by means of a control wheel and a threaded shaft.

Diagonal panning

The artwork on the animation table can be panned in a north/south or east/west direction, relative to the camera lens, by the manipulation of either of the two basic movements of the compound. The moving pegbars makes it possible to move a section of the artwork independently of the respective compound move.

The diagonal pans can be done by a combination of north/south and east/west movements of the compound. Alternatively, the entire compound can be rotated on a bottom rotation, which is only used for positioning, so that either north/south or east/west movements alone can be used to perform a diagonal pan at any chosen angle. This is a great advantage in the case of manual operation where the distances from point A to point B have to be read off the counter and divided by the number of frames required for the duration of the pan, to obtain a constant increment by which the table has to be moved for each frame. This is difficult enough for one move but when two have to be done simultaneously, the chances of making compatible increments are very slight, without deliberate careful planning. Added to this is the problem of 'fairing'. As in live action shooting, it is very unusual to cut to a scene which pans at a constant rate from start to finish. Pans have to be 'faired in' (speeded up) at the start and (faired out' (slowed down) at the end, particularly when they start or end with a static hold.

All the control wheels are fitted with counters which can give readouts in actual distances; combined with the wheel engravings these indications are in thousandths of one inch (0.001 in).

Motorised movements

Although the rostrum camera is fitted with a stop motion motor, it can shoot at continuous speeds of between 30 to 240 frames per minute. By motorising each compound movement and being able to set the speed for each motor individually with a master 'pot' which can control all movements, the shooting procedure can be speeded up enormously. However, this approach is only suitable for stills and other straightforward work which does not require changes of cels or any very delicate manoeuvres.

1

2

1 Rostrum compound allows the artwork to be positioned exactly for each frame.
2 *A* Table top. *B* Table rotation. *C* North/south assembly. *D* East/west assembly. *E*
Bottom compound rotation.

Computerised movements

Computerised control of all movements takes the drudgery out of rostrum camera work. The whole operation is done by simply presetting the start and end positions of a move and indicating the number of frames it should take and the amount of fairing required. There is also provision for selecting the type of exponential curve required for the track. The operation can be done with the camera shooting continuously or frame by frame. In addition to this, some computer systems are built with such a degree of accuracy in repeating movements that it makes the shooting of mattes possible. There are two basic types of computer in use, digital and analogue.

Pantograph table

This is a small table fitted to the base of the stand which can be used to trace unusual movements of the compound such as a pan following a curve in the shape of a letter S or number 8 etc. In non-reflex cameras it is also used to indicate the relative position of the table centre to the lens centre. This is done by means of a pointer attached to the animation table.

Floating pegbar

This pegbar lies just above the surface of the table and is mounted directly onto the vertical column or the base. It has its own east/west and north/south movements and can be used not only to hold a piece of artwork static in relation to the background attached to the table beneath it and moved by it, but also to move that same artwork independently.

The platen

It is necessary for the artwork to be kept flat on the animation table particularly when several layers are being used. A piece of good quality glass (the platen) can be used for this purpose. The platen has to be lifted up before any adjustment in the position of the artwork can be made. To enable speedier operation, the glass is mounted in a frame which is attached to the tabletop. It can be raised with one hand and remains in a fixed position until it is released again by the twist of a handle. The frame also ensures that the glass lies evenly across the artwork with controlled pressure.

106

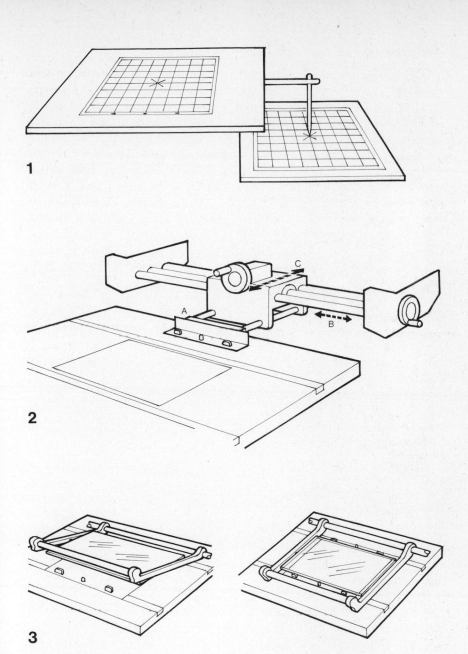

1 Rostrum table and pantograph table with pointer.
2 Floating pegbar. *A* The pegbar. *B* East/west movement. *C* North/south movement.
3 The platen is a piece of plain glass hinged to the table. When it is down, it should hold the artwork without pressing on it too hard.

Autofocus

The change in field size is produced by moving the camera up and down the column or by changing the lens. If the focusing had to be done manually every time a field size change is required, it would be extremely laborious and time-consuming. A continuous tracking shot (a zoom), for example, would take a very long time. Automatic follow focus avoids the necessity for this.

There are two basic auto-focus systems. There is one which uses a cam running the full length of the camera travel, and another which uses a circular cam. In each case the cam is cut to a shape which ensures that the camera focusing mechanism is adjusted to the correct setting for every position on the track by means of interlocking levers. It is also possible to operate follow focus electronically. In most cases the lens is mounted in a separate unit and connected to the camera body by extension bellows, as this allows for extra close focusing down to ratios of 1:1. However, the focusing is sometimes done, not by moving the lens in relation to the camera body as is usually the case, but by keeping the lens in a fixed position and moving the camera body away from the lens. The reason for this is to ensure that the lens moves at a constant rate.

The plane of primary focus can be raised from its normal position at the tabletop level so that very thick artwork, such as books, can be accommodated. This is done by altering the basic position of the follow-focus mechanism.

Zoom rates

When the camera is tracked from the largest field size to the smallest at equal increments for each frame, the resultant zoom appears to speed up progressively. This is particularly noticeable towards the smaller field sizes. This type of tracking (or zooming) is said to be 'logarithmic'. To make the zoom appear to be even throughout its length, the tracking has to follow an exponential curve to ensure a constant rate of increase in the image size.

The calculation of this rate is made on the basis of the ratio between the largest and the smallest field size, i.e. the start and end of the zoom. Naturally this results in a different increment for practically every frame. When fairing in and out are superimposed on this it is no wonder that this type of zoom is not the most popular with cameramen. However, a computer operated animation stand usually has this facility built in.

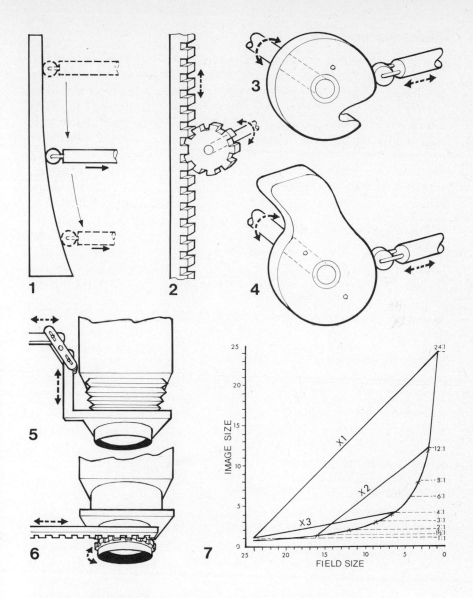

1 Follow-focus cam running full length of the camera travel.
2 Rack and gear for rotating cam system.
3 Auto-focus cam (rotates anticlockwise when zooming in).
4 Inverted auto-focus cam (rotates clockwise when zooming in).
5 Auto-focus drive for normal rotary focusing.
6 Auto-focus drive for lens with bellows focusing.
7 Exponential curves. As camera is zoomed in from the widest to the smallest field size in equal increments, the object photographed appears to increase in size. This increase is not equal along the track because the camera lens is responding to a logarithmic curve. When the camera track follows an exponential curve, the increase in image size is constant.

109

The camera

Basically this could be virtually any camera, although the more sophisticated stands have specially designed cameras with registration pin movements. They are similar in many ways to the cameras used on optical printers. Some have interchangeable movements, 35mm and 16mm, as well as interchangeable lenses. Although non-reflex cameras can be used successfully, they can present a lot of problems. Reflex viewing of some kind is essential for any sophisticated work. The most popular cameras in this field have rack-over reflex viewfinders.

Fade/dissolve facility

The camera shutter is normally of the variable rotary type and is used for executing fades and mixes. This can be done manually or automatically. The length of the fade or dissolve setting varies from 8 to 128 frames.

Capping shutter and autocycler

In addition to the normal variable rotary shutter, some cameras have a built in capping shutter. This consists of a metal blade which is operated by a solenoid from the control console. It is located between the lens and the normal shutter and prevents light from reaching the film gate, regardless of the position of the rotary shutter. During the shooting of an animation 'cycle' where the same series of cels are used in a particular order, the capping shutter serves to 'skip' some of the frames and allow the exposure only on the appropriate ones. On successive passes through the camera other cels are then 'slotted' into their appropriate positions within the cycle. This operation results in only a minimum change of artwork. The entire operation can be done automatically where an autocycler is fitted.

Camera motor

The camera motor can be run continuously as well as for single frame (stop-motion) shooting. The chosen exposure time remains the same in both cases. A selection of motor speeds allows for exposures of between 1 or 2 sec to 1/6 or 1/8 sec. Faster speeds, if provided, are used for rewinding only.

110

Bipack magazines

Single or bipack magazines are available on most rostrum cameras both for 35mm and 16mm operation.

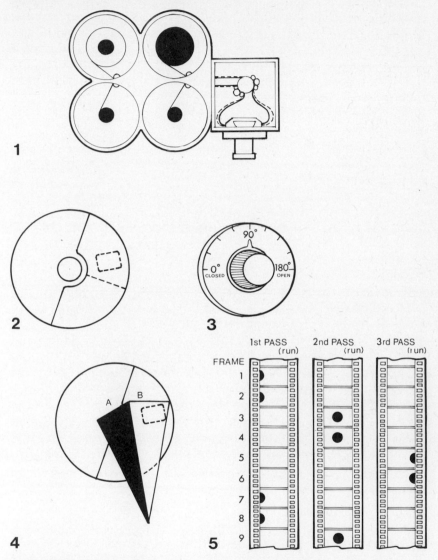

1 Rostrum camera with bipack magazine.
2 Rotary shutter. The sector rotates to reveal the film aperture.
3 Manual control set at 90°.
4 Capping shutter. A Open. B Closed.
5 When shooting a cycle with a capping shutter, instead of changing the artwork each frame (or two) the cycle can be shot in separate passes. The shutter is opened and closed for the appropriate passes.

111

Rotoscoping

The ground glass in a rostrum camera is engraved with frame lines, safe titling areas and frame centres. Lining up artwork is done mainly by projecting this grid (graticule) onto the animation table by means of a lamp attached to the eyepiece. The start and end positions of the shot are noted from counters which indicate the relative positions of each of the compound movements. The shooting itself is done 'blind' because most of these cameras are of the rack-over reflex type. The viewfinder is used conventionally only for focus checks. It also has a facility for registering a piece of film over the ground glass in the same way as it would be in the camera. Film clips can then be projected onto the table, using the rotoscope lamp, for a more accurate line-up of an element which may be added later to the prefilmed scene, or simply for tracing off a particular detail.

For really accurate work, rotoscoping is done through the camera gate itself. A prism is placed in the gate and with the door open a rotoscope lamp can be directed via this prism onto the processed film in the gate. A clear image is then seen projected onto the animation table. The camera motor can be made to stop with the shutter open instead of closed, as is the case during shooting, and an entire scene can be projected frame by frame. This is invaluable where the artwork to be filmed has to match the background action and appear to be, in fact, part of that background action. The artwork on the table is lined up to certain specific points in the picture and then realigned again as these points change on every successive frame. The movements to be made on the animation table are carefully noted. This is a long and tedious procedure, but very often it is the only way of obtaining a high degree of matching between the two elements. Even hand-drawn travelling mattes can be produced by rotoscoping, although these are more successful where regular geometric shapes are involved rather than live action, except for short, quick moves.

Shadow board

This is a board placed below the camera lens to prevent unwanted reflections reaching the lens. It is mounted on an adjustable support which in turn is fixed to the camera support so that it moves with the camera. The aperture cut in the board is used to carry auxiliary optical devices such as ripple glass, etc. A clear glass placed in this aperture can be used to support fixed masks. These are used as 'soft edge' mattes which stay in a fixed relationship to the frame

112

in the camera while the artwork on the table moves independently. A simple device consisting of a threaded shaft and a loose pegbar can be used to move a mask across the frame, progressively obliterating the image. A counter mask (cut at the same time as the first

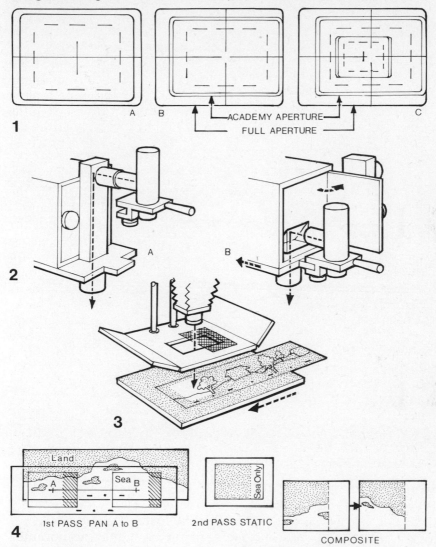

1 *A* 16 mm graticule. *B* 35 mm graticule. *C* 16 and 35 mm graticule combined.
2 Rotoscope lamp. *A* Mounted for projection through the viewfinder. *B* Mounted for projection through the gate via a prism.
3 Shadow board. A simple wipe device.
4 With shadow board matte fixed, the seashore artwork is panned. Then, with the countermatte, sea only is printed in the space, so land appears to materialise from the sea as the pan continues.

mask and therefore an identical opposite) is used on the second pass to reveal another picture or an added element to the first picture. A soft-edged wipe is produced in this way, without interfering with the animation movements of the table or the pegbars.

Lighting

Standard lighting on an animation stand consists of two lamps set at equal distances from the table centre when this is set to line up with the optical centre of the lens. The two lamps are set at the same angle and are positioned at the extremes of an imaginary line, passing through the centre of the table in an east/west direction. The angle of incidence is determined by the area which has to be illuminated evenly. Too narrow an angle produces shadows from upper layers of artwork onto the lower ones; too great an angle is also a problem because then the camera, or specifically the shadow board, can throw shadows on the artwork. In either case there can be an unevenness of illumination produced by each lamp but when the two are aligned accurately this problem is eliminated. An angle of between 30° − 35° to the horizontal is usually the best compromise.

Choice of lamps

The choice of lamp is determined by the type of work that is done on a specific set-up. In general, more light is better because it can always be reduced by filters, whereas inadequate light means that slower camera speeds have to be used and larger apertures to ensure adequate exposure. 2 kw lamps usually provide sufficient illumination for the full range of lighting conditions, although 1 kw lamps are sufficient for most requirements.

Filtration

Special filter holders mounted in front of the lights facilitate quick filter changes but because the gelatins are held at such a short distance from the lights, their life expectancy is greatly reduced. Pairs of neutral density filters and various coloured filters, as well as diffusers, can be kept in a large filter box when not in use. Polarising filters, though, have to be looked after particularly well because they tend to get discoloured when overheated and if too much dust accumulates on them they tend to absorb even more light than usual. They are practically indispensable for toplit work. Polarising axes have to be marked carefully so that the

114

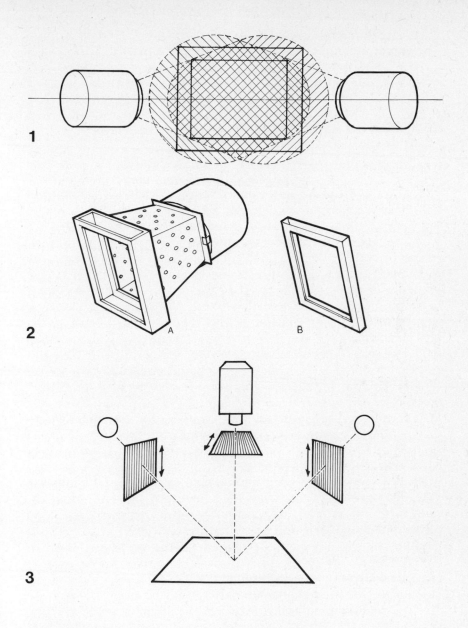

1 When measured separately at the table centre (*X*) each light gives the same foot-candle reading.
2 Lighting hoods. *A* Light fitted with filter hood. *B* Filter mount.
3 Polarising filters in front of the lights, positioned so that their polarisation axes are parallel. The lens polariser is positioned so that its polarisation axis is 90° to the axes of the other two filters.

filters can always be inserted in the filter holder in the same position. The corresponding polarising filter for the lens should be of the same type and set with its axis at 90° to both of the pola-filters over the lights. Type HN 38 is the filter most commonly used for this type of work. The exposure is cut down by approximately 3 stops with the use of these pola-filters (1.5 stops by the filters over the lights and a further 1.5 stop by the filter over the lens).

Backlight

The rectangular cut out in the animation table is used to enable the light to reach transparent artwork, whether it is stills or specially prepared artwork from pieces of coloured gelatin. The backlighting has to be evenly diffused over the entire area. Placing a ground glass in the cut out area is not a good solution because the grain pattern is in focus and is clearly discernible in the photographed image, particularly in the clearer areas of the frame. If ground glass is to be used to help diffuse the backlight then it must be placed at some distance below the top of the table and so out of focus. Opal glass is another useful diffuser but it tends to absorb too much light and some types can alter the colour temperature of the light. In ideal circumstances the backlight should be made to match the toplight so that an average toplit scene and an average backlit scene have the same basic exposure. Normally four times less light is required (in terms of foot candles) for the backlight to match the toplight because of the differences in exposure readings, i.e. toplight is measured by incident and backlight by direct reading. Light reflected from a white card or a laminated white board can produce large areas of even illumination provided the lamps are lined up correctly. Where very high levels of light are required, such as in the case of interpositive printing, then a 2 kw lamp placed under the table and pointing towards the lens can be used. The fresnel lens on the lamp should be turned around and an additional diffuser, such as ground glass, is needed. A strong fan to circulate the air over the diffuser and below the artwork is a must!

Black velvet (or similar material) should be used to cover the animation compound and prevent the backlight from scattering. At the same time, however, the movements of the compound must not be restricted in any way. Apart from the dangers of reflection, spilled light can reach the top part of the artwork and produce a patchy desaturation effect by fogging.

When the rostrum camera is to be used for straightforward printing as a contact step-printer, then a lamphouse can be fitted directly to the camera in place of the lens.

116

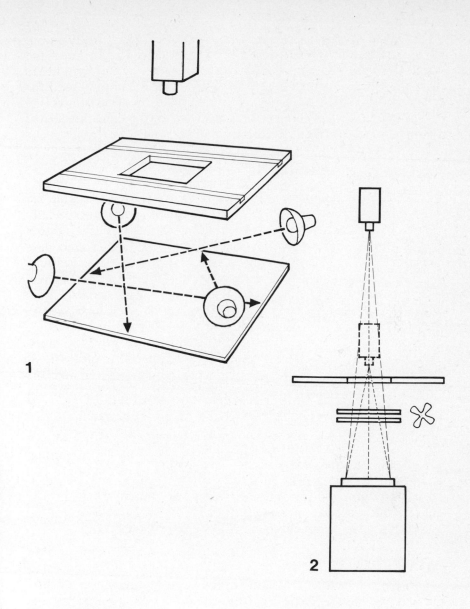

1 Simple backlighting set-up. Four quartz-iodine lamps bounced off a board with white formica top. The lights are lined up to give even illumination over the whole area.
2 Using a 2Kw lamp for printing. To obtain perfectly even lighting over the whole frame, the position is determined by the angle of acceptance of the lens when the size of the light source is limited. A larger working area is obtained on the table top with a narrow-angle lens.

7 Rostrum camera effects

Lens attachments

All the lens attachments discussed earlier in this book can be used on a rostrum camera to produce fragmentation of images, flopping and distortion. In addition a fisheye lens (sometimes available as an attachment to the main lens) offers some specialised uses on the rostrum camera. If the lens is very close to backlit artwork the effect of barrel distortion is pronounced, giving lettering the appearance of being on the outside of a sphere. By panning the artwork, the illusion is created of the lettering revolving around a sphere with letters in the centre of the frame appearing larger, whilst at the edges they appear to recede round the illusory sphere. A scene photographed this way takes on a very unusual appearance. Backlit lettering can be superimposed this way over a normal scene to produce halo effects.

Direct effects

Apart from shooting stills, transparencies and animation artwork directly, a number of very sophisticated backgrounds can be produced entirely on the rostrum camera, particularly in the area of fantasy and science fiction. There is virtually no limit to the number of different passes of a shot that can be made through the camera and the facilities for precision and control are so great that the only limitation is the imagination of the operator. It is not perhaps generally realised that the opening title shot of *2001 – A Space Odyssey* was filmed entirely on the rostrum camera with flat artwork.

Titles

White titles can be superimposed directly onto a prefilmed scene on a separate pass. This can also be a live action scene, shot on another camera. Alternatively, the white titles can be shot on high-contrast stock and used for colour inlaying or drop-shadow treatment by the optical methods already described. The artwork can be either toplit or backlit; backlit material has to be prepared photographically on sheet film, such as Kodalith, with clear lettering on an opaque black background. Toplit material is best prepared on shiny black paper or card. Normal pola-filters set up on the lights and lens ensure that the black background does not reproduce, allowing the lettering to be well exposed without danger of fogging from background reflections. In special circumstances very strong pola-filters (such as HN 22) can be used; however, this material is unsuitable for normal photography because of its adverse effect on colour reproduction.

This black background is all-important because it allows numerous passes through the camera to be made without any special masking. From the simplest frame by frame build-up of a title to a complex break-up of letters, which eventually reassemble into a full title, the only artwork required is a straightforward white caption. Combined with distortions, fades and mixes, focus pulls and additional masking at the shadow board level as well as on the animation table, the number of intricate effects that can be produced with the simplest artwork is unlimited.

Matting

Soft-edged mattes can be produced by masking at the shadow board – the softness of the edge being governed by the distance of the shadow board from the lens and the f stop used.

Masking with glossy black paper at the animation table level produces sharp-edged mattes. Split-screening, wipes (normal and push-off type) as well as image break-ups can all be done with the aid of this type of masking. A fluid matte effect is produced by photographing cels of specially prepared animation artwork which changes shape progressively.

Bipack matting

A graphic mask can be prefilmed on high-contrast stock and carried in bipack as a travelling matte. A simple shape cut out of black paper can be made to spin and move around the table, introducing

119

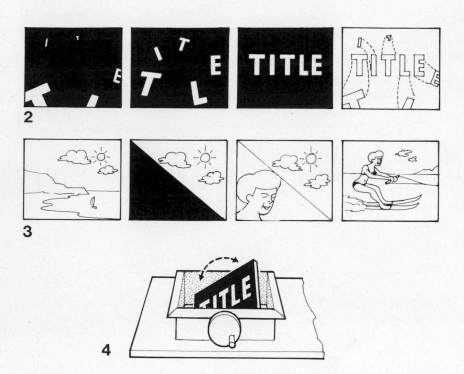

1 *A* The 'halo' effect is only symmetrical when the artwork runs along the centre of the fisheye lens. It can be moved up in frame either by repositioning on an optical printer, or by placing the negative one perforation out of rack in relation to the background. *B* Normal shape produced by the fisheye lens when the lettering is above or below the lens centre.

2 Each letter can be shot in a separate pass, giving it complete freedom of manoeuvre, until it joins up with others to form a word.

3 Split-screen. A section of the screen can be masked off with shiny black paper so that on the second run another scene can be photographed in that area, with opposite masking.

4 Flop-box. This is useful for flopping the image, adding to the three-dimensional effect.

120

a variety of shapes which can then be used as interesting travelling mattes. Running across and zooming into section of a high-contrast graphic representation of a face, or a similar shape, is also an effective way of producing travelling mattes. These travelling mattes can then be used in bipack for direct photography of other artwork on the animation table. Alternatively, a counter matte can be made from the original and two or more different types of artwork can then be married up, joined by the continuously varying shape of the travelling matte.

Bipack printing

The rostrum camera has all the basic features of a contact step printer, when adequate backlight is provided. It can duplicate a master positive in a straightforward bipack printing operation, with the additional facility that titling can be superimposed over the duplicated live scene by direct photography. Parts of the frame can be masked off to produce static mattes, or these can be moved and so change the shape of the matte or even wipe off the image completely. Identical moves can be repeated on a second pass through the camera to duplicate another scene in the unexposed areas. Apart from any additional colour filtration that may be needed, it is always advisable to use a UV filter (2E) in any colour duplicating work.

Projected image

Transparencies available for rostrum work are not often large enough to enable effects involving movements to be made within the picture area. Instead of making normal enlargements, the transparency can be projected by slide projector onto a translucent screen and the enlarged image can then be photographed. In practice, this requires the projector to be mounted in a light-tight housing incorporating a front-silvered mirror at 45° to the projector axis and the back projected material held above the mirror by supports inside the housing. Translucent material such as Kodatrace laid flat on a piece of clear glass, can be used instead of a conventional back projection screen. The projection box is placed on the animation table so that all panning and rotation moves can be done as with a directly photographed transparency. When the focus plane is raised to its new level the auto-focus on the camera allows the zoom to be used as well.

Specially adapted 16mm projectors can also be used in this way to give the effect of filmed action in various areas of the frame.

121

This can also be combined with a mask so that the moving picture appears to be part of a moving object within the frame.

Aerial image projector

The aerial image projector has all the basic features of an optical printer projector head and is specially designed for use with rostrum cameras. A lamphouse and condenser system illuminates the film plane in the projection gate. There is also a means of inserting colour correction filters and neutral density filters in the lightbeam. Intermittent movements are the same as in the majority of optical printer projectors using fixed register pins and include inter-changeability between 35mm and 16mm formats, although some are available for 16mm only. The projector body is mounted on a solid bed and can be tracked along it. It is normally positioned on one side of the animation stand.

The lens

The lens is supported by its own mount independently of the projector body and can be tracked forwards or backwards along the same base. The lens also has the facility for fine movements in the vertical and horizontal plane perpendicular to the lens axis.

The condensers

The projection beam is reflected upwards by the 45° front-silvered mirror set centrally below the animation table. The image is focused at the table top just above the top surface of the two large condenser lenses fitted into the central cutout of the animation table. The maximum working area is about 11 in. The aerial image can be viewed by placing a sheet of greaseproof paper or similar translucent material over the condensers; otherwise it is only visible through the camera lens.

The camera lens has to be at a precise distance from and correctly aligned with the condensers. This means that the camera cannot track and the table cannot be panned. The only movements at table-top level can be made by built-in pegbars or the floating pegbar.

Aerial image and toplights

The great advantage of the aerial image is that it can be used for simultaneous photography of back projected images and toplit artwork. It is possible to have an animated character inside a live

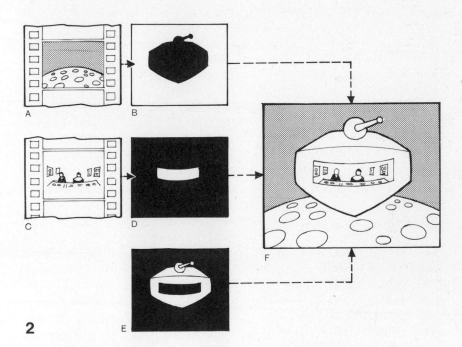

1

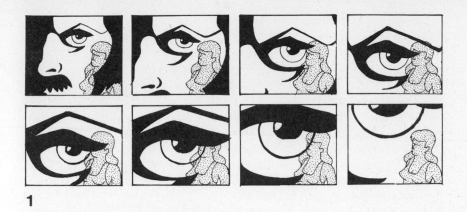

2

1 Travelling matte used in bipack for direct photography of other artwork on the animation table.
2 Bipack printing. *A* Interpositive background action. *B* Cutout of spacecraft lit from behind (windows masked off). *C* Interpositive of live action to be inserted into cockpit. *D* Windows of the cutout left clear; surrounding area masked off. *E* Cutout of spacecraft – toplit (windows masked off). *F* Composite picture.

action scene without the need for travelling mattes. The animation cels are prepared so that they are opaque in the area of the artwork. They act, therefore, as their own mattes by obscuring the projected image whilst the rest of the scene can be seen clearly through the clear areas of the cel. Polarising filters on the lights are essential for this operation.

It is because the aerial image can be seen only through the camera that toplights can be used at the same time, without washing out the image, as would be the case with normal back projection. This also makes it possible to check the balance between the projected scene and the toplit artwork, both in terms of density and colour correction.

Bipack operation

As both the camera and projector have bipack facilities, the aerial image rostrum can be used in much the same way as an optical printer, allowing skip framing, forward and reverse printing, freeze framing, etc. The added advantage is that the projected scenes can be married up with directly photographed artwork in one pass.

The projector bipack facility can be used to carry travelling mattes in the same way as in the camera. Alternatively, two scenes can be run in bipack, producing a double exposure which is different from printing each scene onto the same negative in succession. This is particularly useful where scenes with large clear areas of cel are involved.

Aerial image zoom

The latest development in this area is to produce a zooming effect with a projected image so that enlargements and reductions of the projected image can be made. The camera still remains in its fixed relationship to the condensers and the animation table but the picture projected onto the condensers is enlarged or reduced. This is achieved by placing a copying lens in the lens mount while the standard lens is placed in another fixed mount in front of it. A field lens is used in between these two lenses and it, too, is in a fixed position. A system of servo motors, moves the copying lens and the projector body towards and away from each other to produce enlargements or reductions of the projected images onto the aerial image condensers. An automatic follow-focus system and an automatically operated iris are also interlocked with these movements by means of servo motors.

124

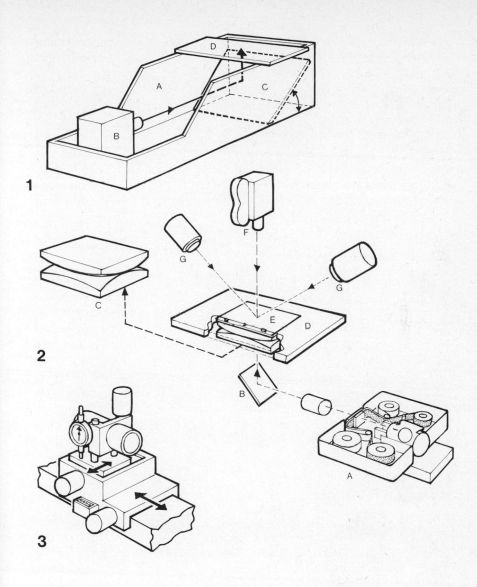

1 Table top projection unit. *A* Black wooden box. *B* Projector. *C* Front-silvered mirror. *D* Back-projection screen.
2 Aerial-image back projection. *A* Projector with bipack magazines. *B* Front-silvered mirror. *C* Condensers; plano-convex lenses to focus the projector image onto the camera gate. *D* Animation table. *E* Focus plane.
3 Projector lens. This may be mounted in its own compound to give precise adjustment to the selection of back projection frame area.

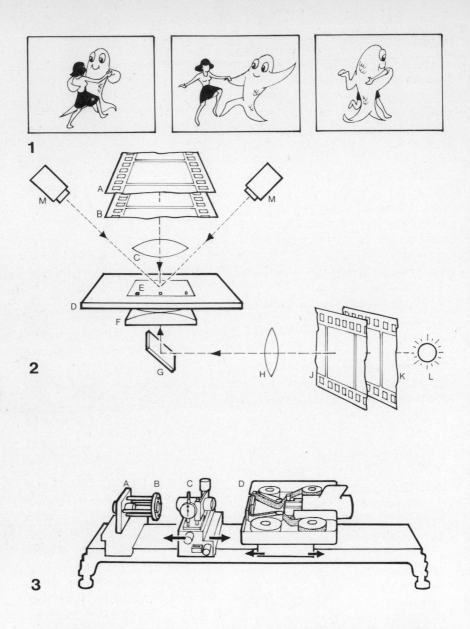

1 By rotoscoping each frame of a live action sequence and tracing out key positions, it is possible to add an animated character dancing with a live action one.

2 Two separate travelling mattes, cel artwork, and a back projection plate can all be used at one time. *A* Raw stock. *B* Travelling matte in contact (bipack) with raw stock. *C* Camera lens. *D* Table. *E* Cel artwork. *F* Condensers. *G* Front-silvered mirror. *H* Projector lens. *J* Back projection plate. *K* Travelling matte in contact with back-projection plate. *L* Projector lamp. *M* Top lights.

3 Aerial image projector with a zooming facility. *A* Standard lens. *B* Field lens. *C* Copying lens. *D* Projector body.

126

Zoptic screen

Even with a zooming capability, aerial image projection has many drawbacks. The camera must remain in a fixed position, making it impossible to do any reframing or zooming on the composite image of a back projected scene and toplit artwork. If the condensers are replaced by a normal back projection screen, the shooting has to be done in two matching passes because the toplights flood the back projected image. However, by replacing the condensers with the Zoptic screen, which is mounted in glass, toplit artwork and back projected images can be photographed simultaneously, as with the aerial image, but with one major difference – there are no restrictions of movement on either the camera or the animation table. Artwork on a clear cel can be moved across the frame on pegbars, or by moving the entire compound, as long as the projected area is covered by the screen. Polarised lighting has to be used with this screen, as in the case of aerial image photography.

The Zoptic screen can be used in conjunction with light, portable projectors (*see* page 139), so that a composite of live action and animation can appear in different parts of the frame as desired. The Zoptic screen can also be used with miniature artwork. (The Zoptic screen is patented and manufactured by Nielson-Hordell Ltd, under licence from the author.)

The Zoptic effect

The Zoptic screen is part of a patented (Zoptic) special effects system which is dealt with fully in a later section of this book (*see* page 169). However, using the Zoptic screen in conjunction with a projector which has a zooming facility, it is possible to create a Zoptic effect without any other equipment. For example, a bird can be made to appear to fly towards or away from the camera using only the basic cycle of wing movements and no extra cels. The movement in depth is produced by a progressive reduction in the size of the projected background as the camera is tracked in (or zoomed) at the same time, at predetermined increments so that the projected image size always fills the frame. On projection, the background appears to stay the same size while the bird is appearing to move closer. The technique is also very useful for flying titles, spaceships, etc. The effect is enhanced if there is a panning or zooming action within the prefilmed background which helps to cover any errors in the camera's tracking.

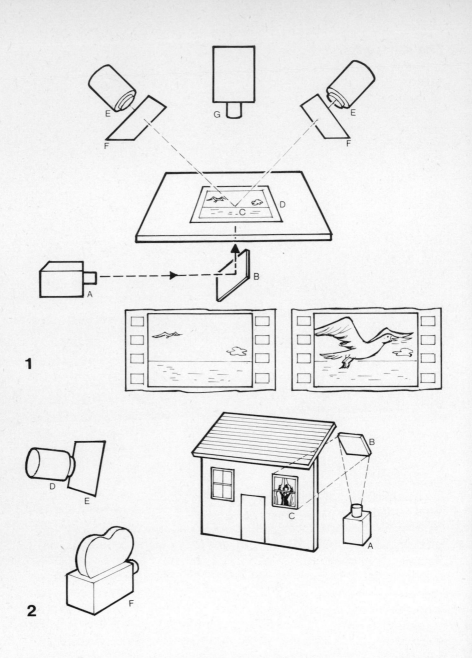

1 Zoptic screen in use with cels. *A* Projector. *B* Mirror. *C* Zoptic screen. *D* Cel artwork. *E* Top lights. *F* Polarising filters. *G* Camera.
2 Zoptic screen in use with miniatures. *A* Projector. *B* Mirror. *C* Zoptic screen. *D* Front light. *E* Polarising filter. *F* Camera.

The slit-scan

Although, ideally, slit-scanning should be done on specially design-
ed equipment, the rostrum camera lends itself extremely well to
the production of this effect with very little modification. The
principle of the system is to expose one frame of the picture while
the camera is tracking. The technique requires that the camera
motor stops with the camera shutter in the open position. An auxili-
ary shutter placed in front of the camera lens is opened at a precise
point at the start of the track and closed at the end of it; the camera
moves on to the next frame and the operation is repeated in
reverse. (A capping shutter can be used for this purpose where
fitted.) This shutter is best operated by a simple solenoid motor
and a microswitch which is activated by two tripping devices
set at the extremes of the track.

During exposure the artwork is scanned through a slit. The
shape of the slit and ratio between the two extreme field sizes
determine the final shape traced out on the film emulsion. Ideally,
both the slit and the artwork behind it should be moving during
exposure but especially the artwork since the zoom will have the
effect of changing the relative position of the slit. This can be
accomplished on the rostrum camera by suspending a large and
fairly thick pane of glass just above the animation table which
carries the artwork. The glass is masked off with black paper
except for a slit. One of the table movements is then interlocked
with the tracking mechanism either by mechanical or electronic
means so that both animation table and camera maintain fixed
relative positions.

The animation within the slit-scan effect is produced by attaching
the artwork to the travelling pegbar and moving it at specific
increments for each successive frame. The artwork is backlit. The
effect produced by slit-scanning can be worked out by careful
consideration of the following points:

During the slit-scanning a point of light becomes a line whose
length is determined by the amount of tracking during the total
exposure time. A 'slit' is made up, in theory, from an infinite
number of these points of light all following slightly different paths
and which can all be traced accurately. However the movement of
the artwork during the scanning effectively changes the characteris-
tics of each spot, so that coloured shapes appear to flow along the
myriads of wavy streaks. Thus, a dot can become a line; a line
assumes a shape; and a shape can appear to be three dimensional.

A back projected prefilmed live action scene can be used in
place of artwork and the slit can then be mounted directly onto the

table top and moved in a predetermined manner and in sync with the track. The entire operation can be made to run automatically.

1

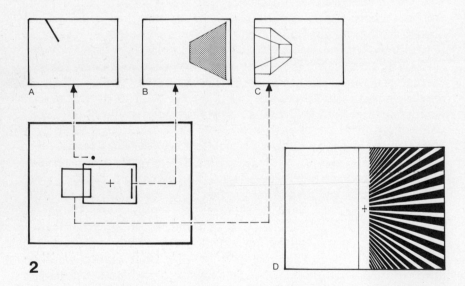

2

1 Slit-scan mechanism. For this system the shutter must be held open for a measured length of time. If there is no capping shutter, a separate shutter can be fitted in front of the lens. Set at *B* (time exposure) this shutter can be operated by a simple solenoid system. *A* Trigger. *B* Micro-switch. *C* Battery. *D* Solenoid (spring loaded). *E* Cable release. *F* Shutter mechanism.
2 Slit-scan effects. By zooming from one field to another different results can be achieved. *A* Dot becomes a line. *B* Line becomes a shape. *C* A shape appears to gain a third dimension. *D* An example of a simple slit-scan.

130

8 Process projection

Back projection

This is probably one of the oldest methods of making composites of live action and prefilmed backgrounds. The actors are placed in front of a translucent screen and the background picture is projected onto it from behind.

Either a still or a movie projector can be used. The movie projector should have a register pin movement similar to that of the camera. In fact, the best known projector for this purpose was manufactured by the Mitchell Corporation using the Mitchell movement. The steadiness of the image is even more important than in the case of optical printers or rostrum aerial image projectors. This is because filming is done at normal live action speeds and sometimes at high speeds and the increase in framing rate makes it much more difficult to hold steadiness.

Motor drives

Both projector and camera mechanisms have to run in absolute synchronisation. If two standard single phase synchronous motors are lined up at the start and switched on simultaneously, they are not likely to stay in sync due to the difference in torque during the run up to full speed. However, by rotating the field winding of one of the motors (usually the one on the projector) during the running, both machines can be synchronised and will stay in sync provided they are run off the same power supply. This oper-

ation can also be done electronically. A certain amount of time and footage is lost at the start of each shot when this method is used. When 220v three-phase synchronous motors are used they can be interlocked by means of a distributor. The distributor is a larger motor of the same type which is driven at the required speed. The three phases of the camera and projector motor are connected to the three phases of the distributor motor; this is a closed circuit whose main function is to keep the motors in step with each other. The three-phase mains supply is also fed to each of the motors and connected to three other terminals. Reversing any two of the three phases changes the direction of rotation. This enables the projector to be run in reverse with the camera running forward. Incidentally, each motor can be run directly and independently of the distributor. The 'selsyn' motors are similar to the three phase motors in the sense that interlocking between master and slave motor employs three phase interlock but the mains voltage supply is only normal single phase. Selsyn motors cannot be used to drive anything directly – they must be driven; the master selsyn is driven by a suitable motor and the slave repeats the movements of the master. A mechanical or magnetic clutch is required to enable the camera and projector to be set in the correct synchronous position when the selsyns are energised. This is because in practice the main drive motor is used for driving the projector directly as well as the master selsyn and also provides independent drive for either the projector or the camera when this is required. To overcome this problem a bigger master selsyn, and two slave motors are used. This method of synchronisation makes it possible to vary the projection/shooting speed from only a few frames per sec to full speed or even 48 fps. Stop-motion operation is also possible. Stepper-motors offer yet another method of electronic interlock.

The lamphouse

A great deal of light is needed for back projection, and therefore very powerful light sources, such as arcs, are often employed. However, the increase in the output of visible radiation is accompanied by a similar increase in heat radiation, which can be harmful to the film plate. Heat radiation can be eliminated to a certain degree either by the use of dichroic filters to deflect the infra-red radiation, or by heat absorbing filters or water cooled units within the optical system or by cooling the film in the projector gate with forced air. It is interesting to note how small a proportion of the entire machine, in the case of the Mitchell projector, is taken up by the projection

132

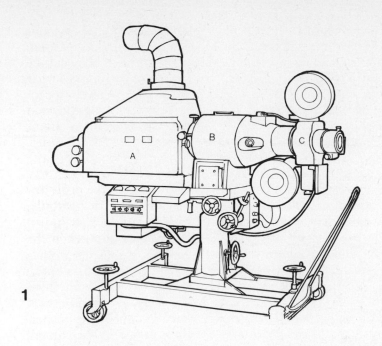

1

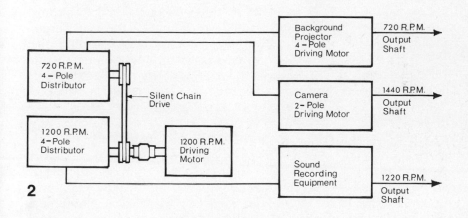

2

1 Mitchell background projector. *A* Arc lamphouse. *B* Optical condenser system. *C* Projector head.
2 Circuit diagram for interlock system of Mitchell background projector.

133

head and magazines; all the rest is the lamphouse and the condenser system. This of course makes it rather unwieldy.

Projection lenses

Projection lenses of the best quality and highest transmission are obviously essential. In some cases it is possible to make special adaptors to take normal camera lenses.

The screen

This is made of translucent plastic material and is available in two basic types. One is dark grey and more suitable for use in situations where the level of ambient light is high. The other type is white. A back projection screen with a high transmission ratio contributes to the fall off of light at the edges which produces a vignetting effect, whilst a denser and more diffused material absorbs more light.

The hot spot

The 'hot spot' is the biggest problem with back projection. It manifests itself in two ways – either as a bright spot at the centre of the screen, where all the light appears to be emanating from, or as an overall brightness in the central area with light falling off at the edges, to give a vignetting effect.

Conventional cinema projectors often have a pronounced fall off at the edges of the frame which is not normally noticed by the viewer. However, the optics used in the construction of projectors used for process photography must give a considerably higher degree of uniform illumination over the entire frame area.

Many different methods have been tried over the years to eliminate the hot spot effect but without any real measure of success. Screens have been made so that they are more opaque in the centre than at the edges; black discs have been placed in the condenser systems or in front of the projection lens to reduce the brightness of the picture in the centre and even back projection plates were specially prepared so that the central areas were more burnt in and, therefore, denser on projection. As a general rule, wide angle lenses produce a greater degree of vignetting than lenses of long focal lengths and this applies both to projector and camera lenses. This inevitably means that the projector and the camera have to be some considerable distance from the back projection screen.

134

1

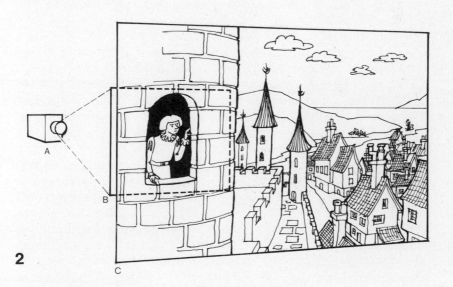

2

1 Bend angles for rear projection.
2 Background projector, projecting a picture onto a translucent screen (*B*) which is set some distance away from a large glass supporting a painting (*C*). The camera pans across the painting from right to left, ending on a close up of the window area and the back-projected image. The camera can appear to go through the window, following whatever action is inside, if this action is already on the front-projection plate.

135

The line up

The back projection screen is set at right angles to the axis of the projector lens and the camera is set in line with the projector. The line up is not absolutely critical although sharp deviations result in fall off and 'keystoning' effects. As the projector and camera have to be considerable distances apart, back-projection set ups are normally horizontal with the screen erected vertically. Angling the screen makes it sag with consequent focus loss and illumination fall off.

Using back projection

Conventional uses of back projection involve projection of backgrounds, usually filmed on location, to blend in with the foreground sets in the studio. In this context, the technique has been long superseded by front projection.

However, there are occasions when back projection is still widely used, as in the case of miniatures.

Models, however well made and photographed, can still look artificial unless a certain amount of live action is incorporated in them such as 'live' images in the windows of miniature buildings etc. If the miniature is made to a reasonably large scale, so that the window area is represented by a fairly large back projection screen, it is possible to create the illusion of going through the window and following an intricate action inside the building. This is done by prefilming the action on a set as it would appear through a window and then tracking into the actor on the set or even following him around from room to room. This 'plate' is then projected onto the back-projection screen which coincides with the window of the miniature set representing the exterior of the house, garden and even parts of the town, if necessary. The camera pans across the miniature, ending up with a close up of the window area, although it is really only rephotographing the back-projected picture. The continued action, if properly synchronised, creates the illusion that the camera has tracked in through the window.

Back projection and matte paintings

A matte painting can be used as efficiently as a miniature set for certain scenes. The painting is done on a large piece of glass leaving a clear area where the back-projected image is to be inserted. The back-projection screen is set at some distance behind the glass to avoid the light, used to illuminate the painting, from washing out the projected image.

Going through the window, or coming out of it is done by staying close on the screen area, so that only the projected image is photographed during the 'copying' stage of the plate. The camera is zoomed and panned across the composite when the projected image matches the cutout in the painting. This approach serves equally well for simple shots such as a zoom-in to close up of a person at the window, as well as for very complex tracking shots inside the building.

Front-axial projection

This system has largely superseded back projection. Much wider screen areas can be covered with less powerful lamps and as the camera and projector are on the same side of the screen there is no wastage of studio space. The actors are placed in front of a highly reflective screen which has the special property of reflecting the light rays back towards the projector lens. The picture is projected via a two-way mirror acting as a beamsplitter and set at 45° to the axis of projector lens. The composite picture is photographed by the camera lens which is positioned behind the two-way mirror in the direct line of the reflected beam.

Front projection screen

The front projection screen is made up of a multitude of tiny glass spheres. Each sphere is aluminised on half of its outer surface and embedded in a plastic support with the clear surface outwards. Each of these 'beads' acts as an optical unit producing total internal reflection. A light ray entering the clear 'window' area of the sphere is reflected internally by the coated back surface, re-emerging through the 'window' and travelling back along its own axis. The front projection system depends very largely on a basic principle of optics, i.e. that light rays can co-exist in the same plane while travelling in opposite directions. Light rays from the projector lens occupy the same plane on reflection from the screen as they do going towards the screen because each light ray is redirected back along its axis by its own 'bead' (sphere).

Front projection material is available in 2 ft wide rolls, with adhesive backing. There are two basic types manufactured by 3M: No 7610 and No 7611. The latter has a somewhat thicker base. The material is overlapped when applied.

It is advisable to follow the advice of the manufacturer as to the best methods of application. The material used for front projection must be of the highest quality and with a minimum vari-

ation in reflectivity between rolls in a particular batch. The rolls should also be tested for any possible variation in quality between the start and the end of the roll and between one side and the other.

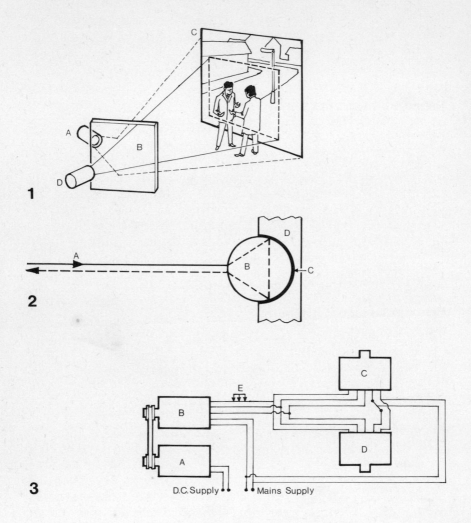

1 Front projection. *A* Projector. *B* Beamsplitter. *C* Front projection screen. *D* Camera.
2 Spherical bead. *A* Light ray. *B* 'Window' of sphere. *C* Reflective coating on outside of sphere. *D* Plastic backing.
3 Basic selsyn interlock system. *A* Main drive motor. *B* Master selsyn motor. *C* and *D* Slave selsyn motors. *E* Three-phase interlock. All three selsyns energised by mains supply.

138

The projector

As in back projection, either a still or a moving picture can be front projected. The Mitchell back projector was originally adapted for front projection work and later specially designed 'one-off' front projectors were produced. At present, there are only two or three manufacturers who offer a reasonably standardised machine. The interlock systems for the camera and the projector are the same as for back-projection techniques. The 'selsyn' interlock system is perhaps the most convenient, allowing probably the greatest versatility. Speeds from 1 fps to 24 fps are possible, as well as stop-frame operation. High speed operation is limited only by the type of projector mechanism used. More recently, stepper motors have come into use. Although somewhat less versatile than the selsyn type, the steppers are smaller and lighter.

The problem of interchangeability of different types of camera on a front projection system has led to the development of a simple interlock system which enables any mirrored shutter reflex camera with its own single phase synchronous motor to be run in synchronism with the projector motor. These motors are all, basically, of the same type. Speeds of either 24 fps or 25 fps are possible with a 50 cycle supply. Synchronising the two machines is done by means of two flashing neon lights mounted on a lever by which they can be moved into the field of view of the camera lens. The lamps are connected to microswitches to indicate the start and end of the 'pull-down' operation of the projector claw mechanism. When both lights are seen as continuous spots of equal brightness through the viewfinder of a reflex camera with a mirrored shutter, the projector and camera are in sync. The projector motor is rotated during the syncing procedure. Once set in sync the two motors keep in step because they are governed by the same voltage supply.

Projector movements

Projector movements like cameras should have register pins. However, unlike cameras, the shutters are normally omitted from the design of a projector mechanism for front projection. The shutter is not only superfluous but a positive disadvantage, because during the actual filming only the foreground action can be seen. The projected image is only visible when the camera and projector shutters are closed. With the projector shutter removed the projected picture is visible during the 'pull-down' operation at least. This picture is far from satisfactory because during the actual

shooting it is not possible to check the synchronisation of the foreground action to the background action as the background appears blurred. However, a blurred background is better than no background at all.

A 'fast pull-down' mechanism makes a vast difference to the quality of the picture during the shooting. The projected picture is seen during the pull-down and also for a short time before and after the pull-down, while it is static. The background action is, therefore, clearly discernible and can be synchronised with foreground action. Usually, the camera movement has a semicircular shutter. The film is held stationary in the gate by register pins for half of the shutter cycle and then pulled down for the next frame during the second half of the cycle. During a fast pull-down movement the action of the claw is performed in only a quarter of the cycle whilst the film remains static in the gate for three-quarters of the cycle.

A small television camera attached to the reflex viewfinder can be used to display the image on several monitors so that other members of the crew, apart from the operator, can see the composite picture. The video picture can be recorded both during the rehearsal and during the actual take, and played back to the actors or for selecting takes before rush prints are ordered.

Beamsplitter

A beamsplitter is a piece of best optical quality distortion-free glass, coated so that a specific proportion of light is reflected and transmitted. The ideal ratio between transmission and reflection is 50:50. However, in practice it is nearer to 40:60. This is not critical because about one f stop of projected light is going to be lost on the way to the screen and about the same amount on the way back from the screen. An advantage gained by using a more efficient beamsplitter to reflect more light towards the screen would be lost by the correspondingly reduced transmission of the image before it reached the camera lens.

Two-way mirrors can be made in thicknesses of between 1 mm and 4 mm. A thin mirror is best because it is less likely that ghosting problems will occur, produced by secondary reflections. However, extremely thin mirrors cannot be handled safely in large dimensions and they can also be distorted easily by uneven pressure from the support frame. 3 and 4 mm are the standard thicknesses used.

The two-way mirror is always used with the coated side towards the projection lens. The other side should have an antireflection coating.

Fringing

A subject placed in front of the front-projection screen is self matting; Projected light is prevented from reaching the screen by the subject. The shadow area produced on the screen by the subject can, in fact, be described as a male matte.

As the screen has such high reflectivity, the projector light falling on the subject is rendered invisible. Even if the subject has white areas, it appears as a silhouette or a matte over the projected picture. When the subject is lit by normal lighting and viewed through the camera without the projected picture it appears in its normal colours but on a black background. The effect is the same as a self-matting positive. When the projected picture is added the composite is complete. If, however, the camera and the projector lens are not lined up correctly, a black fringe appears around the subject, which is in fact the subject's shadow. A fringe on the left side of the subject means that the camera needs to be moved slightly to the right, and vice versa. A fringe around the upper part of the subject is corrected by a slight lowering of the camera.

The exit pupil of the projection lens is that point in the lens from which the light appears to emanate. On reflection from the screen the projection beam converges again towards a spot beyond the beamsplitter mirror. With the camera removed, this spot can actually be seen and examined by blowing cigarette smoke across the path of the beam. The entrance pupil of the camera lens should be coincidental with the spot where the reflected light beams converge. When the camera lens is slightly to one side of this point, the fringe appears on that side. The camera is not viewing the subject from exactly the same angle as the projector lens and, therefore, records the subject's shadow. The misalignment is not restricted to the vertical and the horizontal planes only – it can also be lateral. This fault is eliminated by sliding the camera towards or away from the mirror until the fringe, which may be visible all around the subject, disappears completely. This mismatch gives the appearance of the matte (shadow) being too big or too small for the subject. When it appears too big a black fringe is visible all around, but when it is too small the fringe appears as white ghosting. When in doubt it is always better to go for a white fringe as it is generally less noticeable.

141

Fringing and the zoom lens

When identical lenses are used on the projector and the camera, it is easier to line up the exit and entrance pupils – their positioning is practically equidistant from the beamsplitter. However, when lenses of different types and focal lengths are used on the camera and projector, the exact positions have to be established experimentally. In the case of a zoom lens another problem arises. The entrance pupil of the zoom moves along the lens axis with the variation in focal length during the zooming action; this variation can be considerable and is dependent on lens design. Ideally the camera should slide along the horizontal plane during the zoom so that the entrance pupil always remains in the correct relationship with the exit pupil of the projector lens. In order to allow for panning and tilting action during the zoom, the front nodal point on the lens should be coincidental with the pivot point of the nodal head. The nodal point also moves along the lens axis during the zooming action and the curve it follows is not necessarily in any way compatible with that of the entrance pupil.

Fringing and focus

Focus is also an important element affecting fringing. The projection lens has the same optical properties as the camera lens and is subject to the same laws. Because conventional projection lenses usually have no iris, the concept of depth of field is often overlooked as focus is intended to be in one plane only. *However, this is an extremely important consideration because it is the depth of field of the projection lens which determines the sharpness of the shadow produced by the subject.* When the subject is further away from the screen and nearer to the projector/camera assembly, the edge of the shadow appears soft and fuzzy; when the subject is moved nearer to the screen the edges of its shadow become sharp and clear. The depth of field of the projection lens has the same effect on the focus of the projected image as does the camera lens. If the screen was moved towards the camera without altering its focus setting, the image would not appear soft immediately. For some distance the image would remain in focus and then it would become progressively softer until it was completely out of focus. The factors determining depth of field are the same as with any lens: focal length of the lens, object-to-lens distance and the aperture used.

The best results in front projection can, therefore, be achieved by the following:
1. The subject should be placed as close to the screen as possible.

142

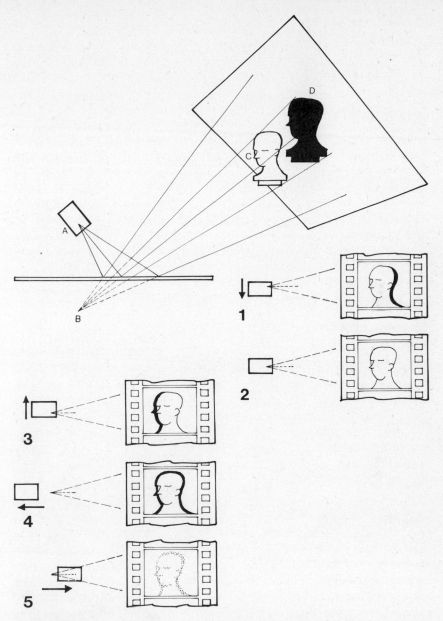

Fringing. *A* Projection lens and the exit pupil from which all light appears to emanate. *B* Light beams converge at this point on their return from the screen. Entrance pupil of the camera lens should be coincidental with this point.

1 Lens too far to the right.
2 Lens in correct position (no fringe).
3 Lens too far to the left.
4 Lens too far back.
5 Lens too far forward.

2. The lens aperture of the projection lens should be stopped down as much as possible.
3. Focal lengths should be as short as possible, consistent with even illumination.

Lining up procedure

Fringing checks should be done at the correct focus setting for both the projector and the camera lenses. This is because the effective focal length of the lens is made progressively longer as it is focused down from infinity. A white disc placed in the position to be occupied by the subject, illuminated so that it is fairly balanced with the background, can be used for this purpose. By moving the disc to the extreme edges of the frame it is possible to establish where the error lies and to correct it. For a very critical line-up it is best to project clear light only. Final checks should be made with both lenses stopped down as required for the shot.

Camera mount

The camera is mounted on a horizontal platform which allows it to be moved backwards and forwards in a straight line along the lens axis. Another plate mounted over this allows the camera to be moved sideways; a keyway ensures that the camera moves only at 90° to the lens axis. The plate which actually supports the camera can also be raised or lowered. Alternatively, a provision for moving the projector towards or away from the camera produces the same results as raising or lowering the camera. Yet another method is to mount the two-way mirror so that it can slide along the lens axis.

The nodal head

The camera mount is normally supported on a nodal head which makes it possible to pan and tilt during a front projection shot. On a conventional camera head, the lens describes an arc during the pan or tilt operation. It therefore moves off axis and the projected image is lost. The nodal head enables the camera to be mounted so that the nodal point of the lens is coincidental with the pivot point of the camera head. Checking the correct line-up of the lens on the nodal head is best done by placing two targets, one behind the other, at some distance from the camera and from each other. When the lens is correctly lined up, the targets do not appear to move in relation to each other during the pan and tilt operation.

144

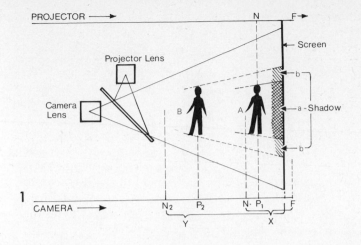

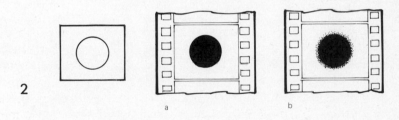

1 Depth of field and fringing. Primary focus of the projection lens is set at the screen (*P*). Depth of field of projection lens has a near focus point (*N*) and a far focus point *F* (beyond the screen). Subject *A* is within the near focus point of projection lens, therefore its shadow will appear sharp. Primary focus of the camera lens is set on the subject and its depth of field *N1* to *F* embraces safely both the subject and the screen. However, when the subject is moved away from the screen to position *B* the camera lens must employ a much smaller *f* stop, in order to hold focus both on the subject and on the screen. If the same *f* stop is used on the projector lens then the shadow of the subject will have soft edges (**2**), because it is out of focus. This in turn makes it hard to match with the sharp edges of the subject which is in sharp focus.

Lighting for front projection

The restrictions in lighting for front projection are not as great as for back projection, but nevertheless they exist. It is a common mistake to assume that because the front projection screen is very direct-ional it does not reflect any other light that falls on it. In practice, spill light has to be kept off the screen, although quite a considerable amount of ambient light is tolerated. This means that full direct lighting is not possible and the cameraman has to resort to finely controlled side- and backlighting. The ideal light source for the purpose should have as near a parallel beam as possible and have a reasonably large diameter, so as to avoid the wastage incurred by masking off a conventional diverging beam. Spotlights and search-lights have the necessary performance characteristics, although it is also possible to modify a conventional lamp.

Skylight

This is a very useful aid in lighting for front projection because it raises the general level of illumination and can be kept away from the screen. It is made up of rows of photoflood lamps wired up in several combinations, so that the light output can be varied. A layer of greaseproof paper below the lights acts as a diffuser and the whole assembly is mounted in a frame and suspended overhead. Black masking around the edges of the frame and a slight inclin-ation away from the screen ensure that the light does not reach it directly.

Polarised lighting

In certain circumstances, such as close-ups, where the subject is close to the screen, the amount of spill light falling on the screen can cause considerable deterioration of the projected image. Placing polarising filters in front of the lights helps to overcome this problem.

Matching the colour

The colour temperature of the projector light source is extremely important for achieving good results. A tungsten lamp with colour temperature of 3200 K, matching the lighting used for the illumin-

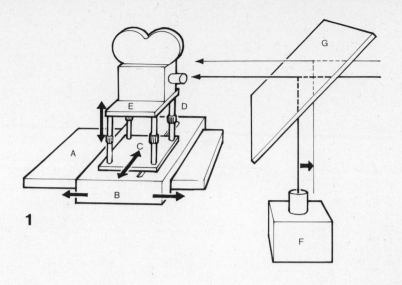

1

2

1 Camera support. *A* Base plate. *B* Support plate for sliding movement to and from the beamsplitter (with guides). *C* Support plate for traverse movement, held in position by a keyway. *D* Left- and righthand studs for raising and lowering the camera plate. *E* Top plate supporting the camera. *F* The projector; sliding the projector towards and away from the camera mount has the same effect as raising and lowering the camera. *G* Two-way mirror (beamsplitter).
2 Basic nodal head. *X* Pan and tilt centre. Nodal point of the camera lens should be coincidental with this point.

147

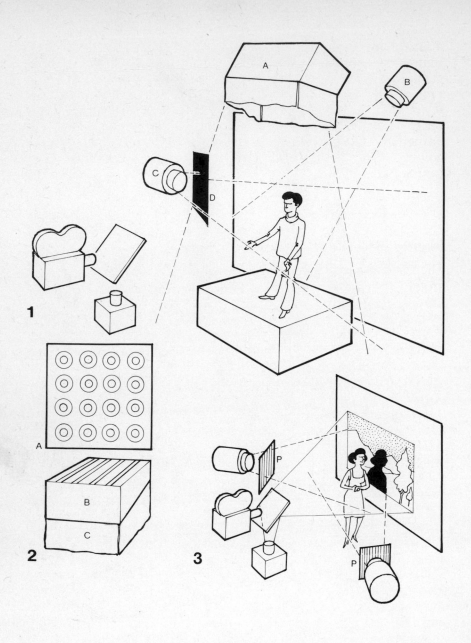

1 *A* Skylight is positioned so that no spill light reaches the screen. *B* Backlight. *C* Side-lights should be positioned so that the shadow produced by them falls just outside the field of view. *D* Gobo.
2 Skylight. *A* Bulb arrangement. *B* Diffusing material. *C* Black skirting.
3 Polarised lighting. It is possible to light the subject more directly from the front when polarising filters are used (*P*) over the lights.

ation of the foreground subject, requires less colour correction than, for example, an arc lamp. However, even with the most suitable light source a certain amount of colour correction is required. This is because the screen material itself has a greenish (cyan) bias and requires correction of around 15 magenta (Wratten series of filters), depending on the particular print as well as the particular batch of front projection material. A certain amount of colour correction can be made during printing of the front projection plates.

Blending-in the foreground

The foreground is first generation but with composites the background inevitably becomes second generation and, therefore, the difference in quality of the two images can destroy the illusion of reality.

Some cameramen use low contrast filters, fogs or a combination of both to overcome this problem. Unfortunately, these filters affect both the foreground image and the projected image, although they have more pronounced effects in situations where sidelighting is used. A reasonably successful blending, therefore, can be achieved if the lighting and the subject are appropriate. Placing a white card in the path of the unwanted part of the projected light beam after it has been reflected through the mirror, results in an out-of-focus image reaching the camera lens, via the mirror. This ghosting can produce a slight fogging over the entire frame area and, therefore, over the subject also.

Producing controlled, even fogging over the entire frame area is another way in which this blending of fore- and background can be achieved. A translucent material (such as a back projection screen) is placed in the 'wasted' light beam in place of the black velvet light trap. Several layers of diffusion and neutral density filters can be added to ensure an even spread and also to cut down the light level. The extent of the fogging has to be determined experimentally, and can vary for different types of scene. Although this method produces a desaturation effect over the entire frame, equivalent to prefogging the negative, it can produce a good match. Naturally this can also be done prior to, or following, the front projection shooting, by exposing the same negative to a predetermined amount of light (fogging). The ideal use of this method is to fog selected areas only. This is usually difficult, however, unless foreground action is restricted to one area of frame only.

149

It is always advisable to rephotograph all parts of a scene in which front projection shots are to be intercut. This makes the final grading much easier.

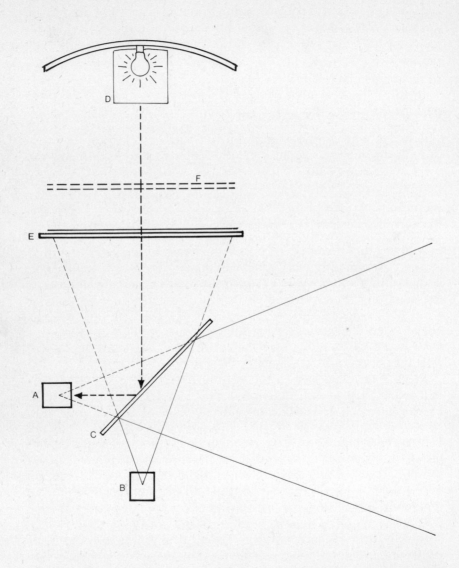

A Camera lens. *B* Projector lens. *C* Beamsplitter (two-way mirror). *D* Soft light with diffusion netting. *E* Diffusing material. *F* Masks can be inserted at this level to restrict the fogging to specific areas of frame.

Front projection plates

Front projection plates are normally made on positive stock but with negative perforations. Projectors can have their registration pins changed to positive if specifically required but this means that the pulldown also has to be adjusted for long pitch.

The advantage of this is that prints made on a continuous rotary printer, in the same way as rush prints, can be used. However, positive perforations are not made with the same fine tolerances as negative ones. Plates made on positive perforation stock are, therefore, likely to be unsteady. Rotary printing also contributes to this unsteadiness.

Ideally, front projection plates should be made on negative perforation stock (short pitch) in contact with the original negative on a step-printer. On those occasions when optical effects (such as skip framing) have to be incorporated in the front projection plate, the optical printer to be used should be checked for steadiness.

The steadiness of the front projection plate can be checked by looking through the camera and observing certain points in the picture against the graticule markings on the ground glass. Static background shots against foreground sets show unsteadiness much more than shots involving movement. Naturally, the camera used in the original filming must have perfect registration – but the same applies to the projector. The projector gate is usually slightly bigger in one corner, so that a perforation can be seen on the screen. This can be used to check the steadiness of the projector mechanism.

Grading

Front projection plates can be made on either normal or low contrast stock, depending on the specific requirements of the scene. In terms of density, lighter prints allow more light to reach the screen, resulting in greater exposure and, eventually, a denser negative. It is advisable to make tests in order to establish the best grading for front projection plates.

A colour chart and a grey scale should always be included on every take in the original filming of the plate. In addition, a standard grey scale and colour chart should be added at the head of each front projection plate, preferably occupying only one side of the frame. This can then be used to match up to a grey scale and colour chart in the studio. It is important that this section of the front projection plate is always printed at a standard printer light, and not affected by the variations in the printer lights for the remaining

scenes. It then represents a constant against which all variations can be checked – including laboratory processing of the plates which is not always infallible!

Exposure

Establishing the correct exposure can be a problem in front projection as the projected image cannot be measured in the normal way. The best method is to light the foreground so that it matches the background (projected image) and then assess the exposure as if for the foreground alone. Matching the grey scale against the projected standard one (as above) is also useful to establish a basic exposure. It should also be remembered that the mirror absorbs between 2/3 and 1 full f stop of light before the final exposure is established. Exposure calculation is further complicated by other factors, such as screen size, T-stop and focal length of lenses, distance from the screen, and the density of the front projection plate. By removing the camera and placing a light meter at the point of convergence of rays of light, it is possible to take a reflected-light reading of the projected scene. A spot meter is particularly useful for this purpose as it allows readings to be made of certain specific points within the picture. Alternatively, a mirror placed between the camera lens and the beamsplitter can be used to redirect the light beam, where it can be read easily.

This method can produce inaccurate readings if the meter is not placed in the correct position. A far better method is to take the reading in the camera gate itself with the help of a fibre optic probe and a clip of frosted film which is laced up in the camera gate. Ideally, a special unit can be made to enlarge the image which would normally fill the camera gate and have it displayed on a ground glass where it can be read and examined very accurately. This enlarged image could also be photographed on Polaroid film to check both the overall exposure and the relative balance between foreground and background. This requires a special capping shutter to be placed in front of the light source and synchronised with the shutter of the stills unit.

Once the basic exposure is established for a given lens and a given density of front projection plate, the light output of the lamphouse should be checked from time to time to ensure a consistent performance. This can be done by projecting clear light and taking a reflected reading as above, or by taking an incident reading at a specific distance from the projector lens.

Once all this information is available it is relatively easy to compute the variations in exposure which occur when one or more

of those elements are altered. For example, an increase of $2f$ stops of light output from the projector is required every time the working screen size is doubled.

Setting up a front projection shot

Under ideal circumstances a lot of planning goes into the composition and execution of a background plate. It is important to know the lens used in the original shooting, as well as the height and inclination, so that the correct perspective can be achieved

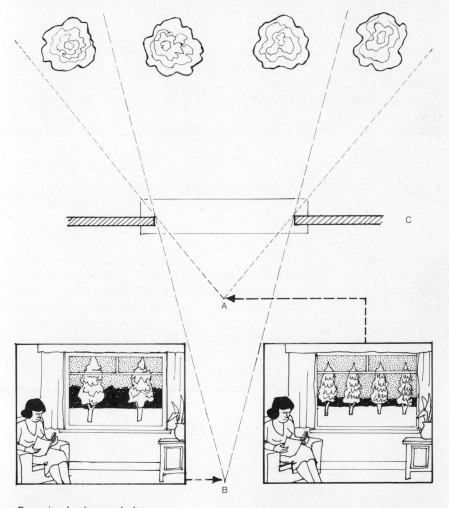

Preparing background plates.
Shooting through the same 'window', the background appears different when shot on wide-angle lens (*A*) then when it is shot on narrow-angle lens (*B*).

in the studio. It is advisable to have a stand-in in the position of the actor for a few feet at the start of the shot – to ensure a perfect match with the background. This is even more important for front projection than for back projection because there are virtually no restrictions on the camera angles, and therefore very careful notes have to be made at the time of the shooting. Various 'markers' can also be included in the areas of frame which will be masked off by foreground set pieces.

In those cases, for example, where the background action is to be seen through a window only, it is wiser to shoot slightly more than the window area on a full frame, even though the window area forms only part of the composite picture. The quality of the projected picture is undoubtedly increased this way and it is easier to make it look 'real'. However, the lens angle used for this also determines whether the composite looks realistic or not. If a telephoto lens is used to shoot, for example, the area seen through a window, objects in the background appear nearer than if a wider angle lens is used. It is most important, therefore, that the specific effect required in the final composite is known and understood by every-one concerned. Ideally, the whole sequence involving front pro-jection should be storyboarded and detailed sketches prepared for each composite shot.

Shooting off the mirror

As described earlier, it is possible to make camera moves within the front-projected picture, if the camera is mounted so that the nodal point of its lens coincides with the pivot point of the pan and tilt head. The action can therefore be followed, as in conventional shooting. This inevitably means that the projected picture is enlarged, unless of course a larger format is being used in the projector than in the camera. On occasions the front pro-jection area is to one side of the studio set instead of directly behind it. In such a case it is possible to pan from the front-projection picture to the set, without enlarging the background. The camera pans off the two-way mirror. The edge of the mirror is cut at an angle to produce a straight line which is lined up with a suitable point in the background. The bevelled edge of the mirror is in-visible because it is close to the camera and, therefore, out of focus. However, it should not be forgotten that the mirror absorbs light, therefore the set has to be lit accordingly so that no change in the exposure is discernible during the pan. A mirror with a high transmission to reflection ratio is more suitable for this purpose.

154

Going 'behind' foreground objects

Front projection material can be applied to a section of the fore-ground set so that the projected background can be seen in that area of the frame. Apart from the possibilities for some really crazy composites, this technique can be used to make actors appear to go behind objects in the foreground. Naturally this is only possible with static set ups. Foreground objects which follow certain geometric shapes can be lined up more easily. For example, a foreground wall can be reflected off a small screen placed in front of the main screen, so that the actor can go behind it. Apart from adding realism to a scene, this approach can also be used to

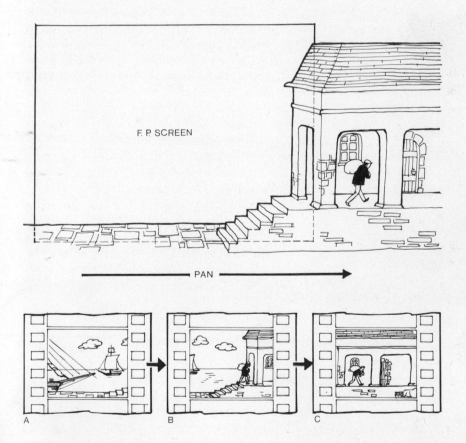

Panning off the mirror.
A Front-projected picture with a little foreground.
B Half-way through the pass — edge of the mirror is lined up with the edge of the house.
C Studio set — camera has panned off the front projection picture completely.

create certain 'impossible' effects. Graffiti can appear to animate on the wall as the actor goes behind it. (Animated lettering painted directly on the wall and photographed stop-motion would of course be done in the original shooting of the plate.) A nodal pan across the picture following the actor makes the movement of the graffiti even more convincing.

The main consideration with this type of set up is that the foreground image should appear sharp. Image sharpness is determined by the depth of field of the projection lens. The choice of lens, which affects the f stop and thus the light output of the projector, and the distance of the foreground screen from the main screen, all determine whether such a set up is a success or not.

The small section of screen, used to reflect the foreground image, appears brighter than the main screen because it is nearer to the camera/projector assembly. Neutral density filters, carefully cut to match the shape of the foreground object, can be used in front of the projector lens. Cutting down the reflectivity of the front projected material itself has also been tried with varying degrees of success.

Masking off

Front projection material is sometimes used to mask foreground objects, for example, a crane arm holding up a car. All the problems mentioned above apply also to this technique. With certain backgrounds this type of masking can be successful, but it is far from being foolproof.

Masking off the ground below an actor's feet is particularly difficult. A specially prepared platform with overlapping slats onto which front projection material has been applied can be used successfully in certain situations. Generally, however, it is better to build real floors for actors to walk on.

Front projection and matte paintings

Matte paintings on glass can be used in conjunction with front projection in much the same way as with back projection. The glass has to be angled a little to avoid flare from the projection beam. If a polarising filter is used in front of the camera lens and polarised lighting is used for the illumination of the matte painting, then the front projection material can be at the same level as the painting. This offers interesting possibilities because the front projection material can be applied over a painted area and then cut out and peeled off as desired, to produce a perfect match.

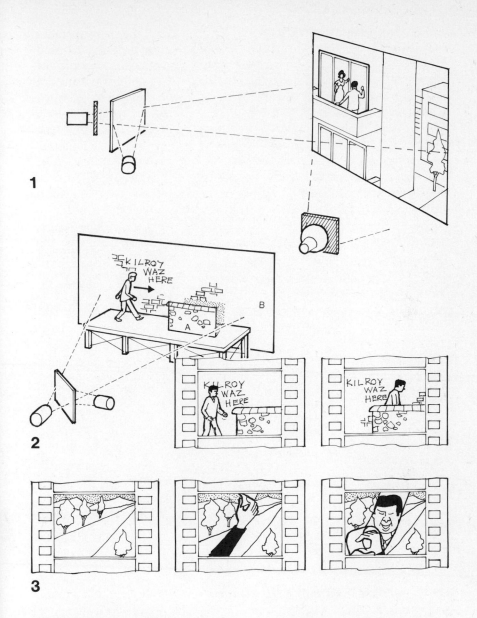

Front projection and matte paintings.
1 Matte paintings on glass can be used in conjunction with front-projection. The glass has to be angled a little to avoid reflections. If a polarising filter is used in front of the camera lens and polarised lighting used for the illumination of the matte painting, then the front projection material can be at the same level as the painting.
2 Foreground wall is reflected off a small screen placed in front of the main screen so that the actor can go behind it. This method can be used to create certain 'impossible' effects. Graffiti can appear to animate on the wall as the actor goes behind it.
3 A hand can peel off the front projection material to reveal another scene.

157

This approach makes it possible to achieve some interesting transitions. For example, a hand is seen to peel off a section of front projection material and the 'live' scene can be replaced by the painting in that area. It can also be used in conjunction with the Zoptic back projection screen, or a conventional back-projection screen placed at some distance behind the glass. The scene to be revealed could be part painting and part 'live', or it may not have a painted element at all.

Ghosting

The most common configuration in front projection units is for the projector to point vertically upwards and the camera to lie in the horizontal plane. The beam from the projector, which is not reflected towards the front projection screen, passes through the beamsplitter onto a light trap (usually black velvet). However, by using another configuration whereby both the camera and the projector lie in the horizontal plane at 90° to each other, it is possible to photograph another image set at 90° to the lens axis. This image appears to have reversed geometry (because it is seen via the mirror) and because it is in no way matted into the projected scene, it appears to be transparent. A 'ghost' can be made to move in and around a front projected scene which includes other actors which are properly matted in.

Flames

The same set up as above can be used for simulating flames to create the effect of a building being on fire. The outlines of the building are traced onto a large sheet of glass and a black paper mask is placed over these outlines. The 'flames' are placed in the correct position. A nodal pan across the static scene, adds an extra feeling of authenticity.

Front projection and miniatures

Miniatures can be incorporated into a front projected scene using the same set up as above. Naturally the area of the miniature has to be masked off so that it does not appear as a 'ghost' in the front projection scene. If the miniature is placed in front of a black backdrop it is effectively 'self-matting' but a male matte corresponding to its outlines has to be placed between the projector and the screen. Actors in front of the screen can appear to go behind the

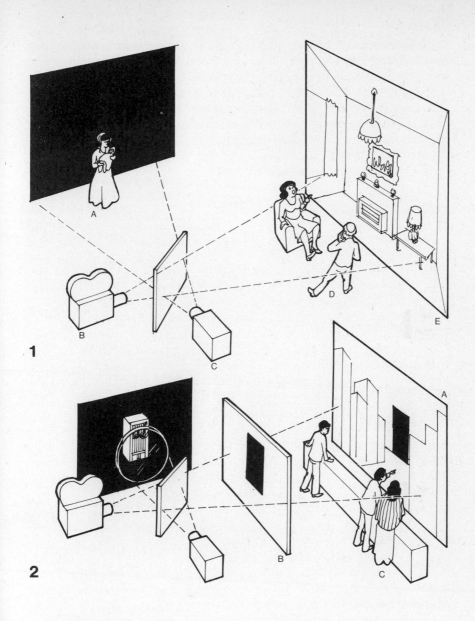

1 Ghosting. *A* Image set at 90° to lens axis. *B* and *C* camera and projector in the horizontal plane at 90° to each other. *D* Live actors. *E* Front projection screen.
2 Front projection and miniatures. Miniatures can be incorporated into a front-projected screen using the same set-up as above, but the miniature is masked off to prevent ghosting. *A* Front-projection screen. *B* Male matte painted on glass. *C* Live actors.

miniature because of this mask. This is particularly useful when the building represented by the miniature is to be destroyed by fire. A photograph or a painting can also be used in this way.

To make the miniature appear sufficiently large in the frame and still keep it in focus, it is often necessary to use a supplementary lens. This large positive lens, allowing close focus, is placed as close to the camera lens as possible but at 90° to its axis and beyond the two-way mirror, so that only the focus of the secondary image (the miniature) is affected.

Dual screen system

Roughly half the amount of light from the projector is reflected by the beamsplitter towards the front projection screen, while the other half is transmitted. This wasted portion of the projection beam is usually absorbed by a black velvet light trap. However, by placing a secondary front projection screen in the path of this wasted beam, at the same distance from the projector as the primary screen, the same projected image can be redirected back towards the camera lens. In this way the subject placed in front of the primary screen appears semitransparent. The 'ghosting' effect is produced by the reflection from the secondary screen onto the subject as, obviously, the secondary reflection has no matte for the subject and reproduces the background picture in its entirety. In this form the system has very little practical use. However, by placing a large dioptre lens above the beamsplitter, the secondary beam can be brought into focus at a relatively short distance from the projector, thus requiring a much smaller secondary screen which can then be easily attached to the projector/camera assembly. In this way scenes which would normally require very large front projection screens can be filmed on relatively small screens, by complementary masking of the images reflected from the two screens. It also makes lighting easier because the spill light has to be kept off a smaller area and the lights can be brought in nearer to the subject. Consequently, frontlighting is possible to a greater degree than if only one large screen were to be used.

There are some drawbacks to the dual screen system. Firstly, because the secondary beam has to pass through the clear glass of the beamsplitter, after being reflected from the screen and before being reflected into the camera lens by the coated side, a certain amount of ghosting appears over the image. The reason is that a certain amount of light is reflected by the uncoated glass surface itself and so produces a faint image which is not quite in register with the main image. The result is poor resolution of the main

160

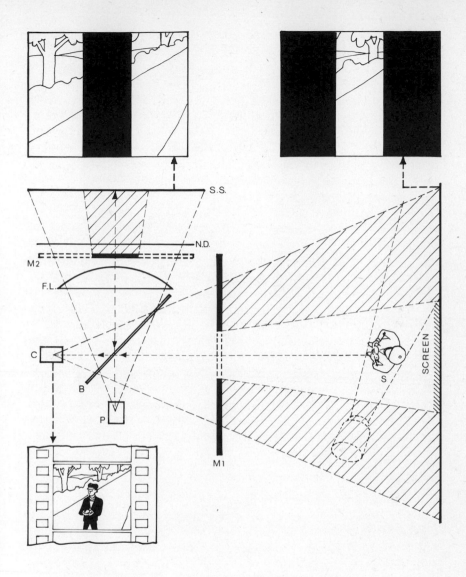

Dual screen. *P* Projector lens. *C* Camera lens. *B* Beamsplitter. *M1* Mask (male). *M2* Counter mask (female). *FL* Field lens. *SS* Small screen. *ND* Graduated neutral density filters. *S* Subject.

161

image. This effect can be minimised to a certain extent either by using a special coating on the nonreflecting side of the beamsplitter, or by the use of extremely thin beamsplitters (pellicles), or prismatic cubes.

A second drawback lies in the matching of the masks which obscure the unwanted areas from each of the two screens. Masks placed at equal distances, on either side of the beamsplitter, normally have equally soft edges. However, since the dioptre lens is usually close to the beamsplitter, the mask for the secondary screen image has to lie above it and therefore appears sharper. The mask used in front of the primary screen has to be moved away from the camera lens until the softness of its edge matches that of the second mask. Once this is achieved the two images can be blended together relatively easily.

The final difficulty to overcome is that as the secondary screen is very much nearer to the projector than the primary screen, the image reflected from it is much brighter.

Two graduated neutral density filters are used to achieve the correct balance. Masking between the two screens can also be done by placing a front-silvered mirror in the path of the beam to redirect a portion of the projected picture to the primary screen. The silver is removed in specific areas of the front-silvered mirror, so that part of the image can go through the glass onto the supplementary screen. This self-matting method offers great possibilities. The two-way mirror is turned around so that the reflecting surface is directed upwards, avoiding the problems of double reflections.

Suspension methods: wires

When no foreground sets are used, the subject can be suspended in front of the front projection screen on wires. This method is successful with light objects because very thin wires can be used. Thicker wires, such as those used for supporting the weight of a man, cannot be used successfully in front projection. They are more difficult to disguise with front projection than with conventional lighting, as the wires throw shadows which can appear wider than the wires themselves. Even a well-lit wire which matches the background becomes too conspicuous.

Vibrating wires can be made to look less obtrusive but their performance is inconsistent as soon as they are used to actually manipulate the subject, instead of merely keeping it suspended. Generally speaking, wires are a problem in front projection; even when all the other difficulties are overcome, the subject is not easily manoeuvred by this method.

Painting out wires

In those circumstances where wires have to be used in a front projection shot they can be eliminated optically. Inevitably this means a duplicating stage where the bad sections of the frame (those with wires) are replaced with the good sections from a clean duplicate print, which does not include the foreground. It is best to shoot a 'cover', without the foreground action, at the same time as the wire composite is made. This avoids differences in framing and colour balance, which would complicate the job even further (*see* page 149).

Suspension methods: the pole

The best way to suspend a subject for front projection is by means of a pole pushed through the screen. The camera/projector assembly is set up in line with the pole, so that it is automatically masked off by the subject it supports. The screen has to be of rigid construction so that holes can be cut in it for the pole. The pole is attached to a rig at the back which stands independently of the screen. When heavy weights are involved, the pole support base should be extended under the screen in the same direction as the pole. The subject can be attached either directly to the end of the pole or via a set of mechanical joints enabling the subject to be manipulated up and down as well as sideways. The pole can also be constructed so that it rotates – thus giving yet another movement to the subject. More than one pole support can be used at the same time, provided that they all point towards the camera lens.

Lightweight projectors

The tendency recently has been to make small, compact, front projection units which are easily manoeuvrable. The replacement of the old arc lamp by compact light sources has made the production of mini units possible. The first front projection units were looked upon as replacements for back projection units and all the restrictions commonly associated with this system were simply transferred to front projection. Static set ups with static foregrounds and fixed foreground pieces were the most common types of shot done in this way. The projector normally remained in a rigid position and any panning or tilting was done on the nodal head. The set-ups were generally in or near a horizontal position as in the case of back projection. However, with the advent of lightweight projectors, it has now become possible to shoot at virtually any angle.

163

1 Pole mounted through front-projection screen.
2 Neilson-Hordell dual screen front matte projector.
3 Hansard mobile front projection unit.

Moving the front projection assembly

If the front projection assembly is mounted on a dolly running on tracks parallel to the screen, then the entire assembly can be crabbed along during the shot. There is no visible effect of this crabbing movement as far as the projected image is concerned, but the foreground action appears to glide across the picture

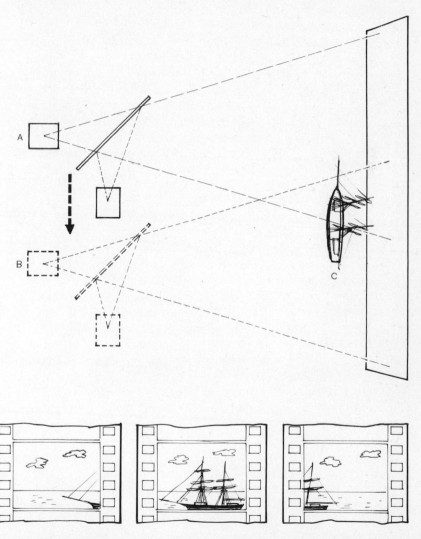

Tracking the front projection unit from position *A* to position *B* creates the effect of the subject *C* appearing to travel across the screen. Alternatively, the front-projection unit can be panned left to right to produce the same effect.

165

although it is, in fact, standing still. In this way an actor in a boat can appear to sail across the picture in the foreground while an appropriate seascape is projected in the background; a prefilmed movement in the opposite direction on the background plate enhances the effect further. As the boat is really in a stationary position it is easy to give it a slight rocking and pitching movement which makes it blend even more realistically into the background. If the projector/camera assembly is mounted on a rotation ring then the above effect can be produced by simply panning the entire assembly from side to side. The keystoning effect of the projected picture is automatically compensated for by the camera lens, so that the photographed image looks the same as when the projector is at right angles to the screen. The inherent depth of field of the projection lens ensures that the side of the picture affected most by the keystoning remains in focus. In addition, the properties of the front projection screen material are such that the reflectivity remains much the same, with viewing angles of up to 45°. In practice, both crabbing and panning would be used in the above shot because crabbing produces a change in perspective. In addition, tilting the projector/camera assembly makes the boat appear to bob up and down on the waves.

Rotation

Mounting the projector/camera assembly on a rotating platform, so that the centre of rotation is coincident with the axis of the projection lens, can also give the effect of the foreground subject rocking and spinning. This is done with the aid of a large front-silvered mirror placed in the path of the projector light beam above the beamsplitter, where the light trap is normally situated. This mirror is mounted independently of the projector and at 45° to the projection beam. The beamsplitter is turned around so that the coated, reflecting surface is facing the camera instead of facing the projector. A black light trap is placed directly in front of the camera and beyond the beamsplitter. The projection beam passes directly through the beamsplitter onto the front-silvered mirror and is redirected to the screen. On the way back from the screen the light is reflected by the beamsplitter into the camera lens. The picture on the screen appears to tilt because the front silvered mirror remains static while the projector is rotated around its axis. Since the camera is seeing the same projected image at all times this movement is seen as tilting of the foreground subject only while the background remains unaltered. A rotation of 180° makes the subject appear upside-down in relation to the background, and a

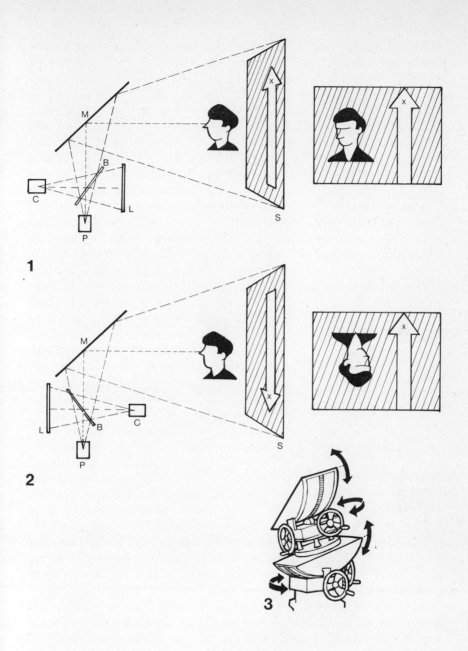

1 Subject and background normal way up.
2 Subject appears to be upside down. *C* Camera lens. *P* Projector lens. *B* Beamsplitter. *L* Light trap. *M* Front-silvered mirror. *X* Projected image.
3 Miniature front-projection units can be mounted on two geared heads for greater flexibility.

full rotation of the projector/camera assembly during filming makes the subject appear to rotate within the frame.

Double pan and tilt heads

A compact front projection unit can be mounted on a conventional pan and tilt head and operated with the same degree of freedom as a camera. Two pan and tilt heads placed on top of each other allow for a rocking movement to be added to the pan and tilt.

A miniature front projection unit of this type can be used to induce movement in a subject with great accuracy. The apparent movement can also be extremely intricate especially when combined with a certain amount of manipulation of the subject itself on the pole.

As it is light in weight, this type of unit can be mounted on a conventional dolly and used for combining conventional filming with front projection. For example, a scene can be shot of an actor, with a front projection screen behind him, apparently talking to another actor (or even himself) who has been prefilmed on the front projection screen. From this composite the actor walks away from the projected area and into the set with the camera following him as it pans off the two way mirror. Once the camera is off the mirror, the camera dolly can be moved anywhere within the set, continuing to follow the actor as in conventional shooting.

Movement in depth

Movement in depth is probably the most difficult of all optical effects to achieve, whether it is a man walking along the street or an aircraft flying. For the subject to appear to move inside the picture in one plane, up, down or sideways (and even to rotate) the front projection unit simply has to be moved in the opposite direction. However, when it comes to movement in depth, ie when the subject is meant to move towards or away from the camera as well, then the problem becomes altogether more difficult.

Take a model of an aircraft as a basic example. It is obviously essential that it must appear to fly 'in depth' if it is to look realistic. This means that the aircraft must be moved physically towards the camera. The pole through the screen, therefore, cannot be used as a means of suspension. Wires can make it move in depth, but all the accompanying problems then have to be resolved. Additionally, physical movement of this type creates another more fundamental problem. If the aircraft is to appear appreciably big in the frame, it has to move relatively close to the camera and consequently a lot

further from the front projection screen than is desirable. The restrictions created by a combination of fringing problems and wires makes it impractical to attempt this type of effect in front projection. Until recently it has had to be done in some other way, ie travelling mattes.

Zoptic front projection

Zoptic front projection is a patented system which creates an apparent movement in depth, while the subject remains in the same

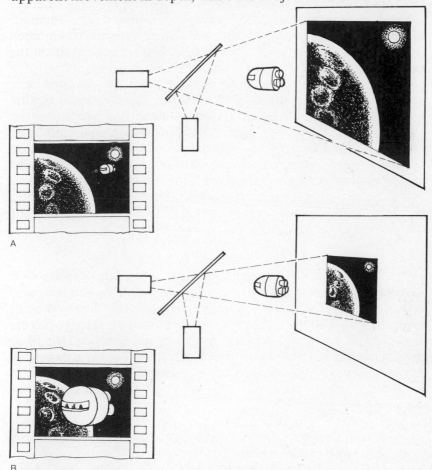

Zoptic effect.
A Projector lens projecting a large picture on the front-projection screen (wide-angle) and camera lens set on wide angle. The subject appears small against the background.
B Projector lens zoomed in, projecting a small picture on the front projection screen and camera lens zoomed in correspondingly. The subject appears much bigger than in *A* although the backgrounds appear the same.

relative position to the screen and the front projection unit. This is achieved by means of two identical zoom lenses – one on the projector and one on the camera. The zooming operation of the two lenses is done in synchronism so that while the projector lens is projecting a large picture on the front projection screen (wide angle) the camera lens is also set on wide angle, photographing the same size picture as is projected. When the projector lens is zoomed in, projecting a small area on the front projection screen, the camera lens is zoomed in covering the corresponding small area. In the camera viewfinder the projected scene does not look different whatever setting the two zooms are on, as long as they remain interlocked. However, a subject placed in front of the front projection screen appears small against the projected background when the zooms are at a wide angle setting, and appears very much bigger when the zooms are at a long focal length. The background, however, remains relatively unchanged in size. Because of this apparent increase in size, the subject appears to have separated from the background and moved forward towards the camera. It is, in fact, the background that moves (changes in size) while the subject remains static, but the illusion is created that the background appears static (constant) while the subject appears to move.

The flying rig

A lightweight front projection unit equipped with the Zoptic system is the ultimate method for producing flying effects. *Superman – the movie* was the first film to make extensive use of this system.

Nodal head panning and tilting can be sacrificed altogether on a flying rig, to make it lighter and more manoeuvrable. By motorising all the movements and programming them into a computer controlled unit, it is possible to rehearse a shot until it is perfect and then shoot it, achieving a composite with very intricate moves in one 'take'.

Zoptic without zooms

The Zoptic effect can also be achieved by using fixed focal length lenses instead of zooms. This requires that the front projection unit is tracked towards the screen. A servo-motor system controls the autofocus of both lenses as well as enabling a progressive reduction in light output. This system is much less flexible than using zooms. The apparent speed of the movement in depth is limited by the physical speed of the projector unit on the tracks. However, it has one major advantage in that lenses of much wider aperture

The flying rig. Lightweight front projection unit equipped with the Zoptic system, for producing flying effects.

can be used with the result that larger screen sizes can be covered by the same small light source. In addition to this the zooming range is limited only by the size of the stage.

Shot planning

Naturally the precise angle and perspective of the shot must be carefully chosen before the background plate is made. The Zoptic effect can be worked out in detail on paper because it follows strict geometric rules. The path along which the subject appears to move in depth through the picture, is the extension of a line drawn from the centre of the frame (optical axis) through the centre of the subject. Two more lines drawn from the frame centre to the extreme points of the subject and extended to the edge of frame give the wedge shaped path along which the subject appears to travel.

If an actor is required to run at incredible speed along a road towards the camera, the precise position of the road in the frame is extremely important. It is best to line up the shot with a stand-in actor in position. If the horizontal centre-line of the frame is set to cut across his waist when he stands on the road and the camera is positioned at this height, then no further adjustments are needed during front projection. Both the upper and the lower parts of the body appear to grow in size in equal proportions as the actor nears the camera and his feet always appear to remain on the ground.

If, however, the perspective is not matched in this way, the actor's feet appear to move below the road or above it. To compensate for this the camera/projector compound has to be correspondingly tilted during the shot.

If a shot is properly planned, so that the actor's feet are on the horizontal centre line, they stay on this line throughout the zoom and as he increases in size he appears to move away from this line towards the edge of the frame.

This is particularly useful when people or objects are required to appear to shrink or grow while standing in a specific spot. If, on the other hand, the actor is fully in frame at the start of the shot with his feet near the bottom frame line and is required to 'shrink' to a very small size on the same spot, then the camera/projector compound has to be tilted upwards during the shot in order to keep his feet in the same apparent position in the scene.

The position of the object relative to the vertical centre-line is also of equal importance. A man standing on the horizontal line and on the vertical centre-line grows or shrinks on the spot, without the need for any compensation. However, if he is standing to the right of the vertical centre-line with his feet still on the hori-

172

A and *B* Two ways of calculating and representing a 10-1 zoom on a man running. *C* No compensation is needed for a glass to grow when positioned with its base on the horizontal centre line with the vertical line cutting down the centre of the glass.

173

zontal centre-line, he 'drifts' towards the right edge of the frame as he grows and his feet appear to slide along the horizontal centre-line. In this case a left-to-right pan of the camera/projector compound is required to keep him on the same spot.

This type of compensation is not difficult to achieve as the actual effect can be seen as it is being created and appropriate correction can be made when required.

Using the Zoptic

The obvious applications of Zoptic technique are for making objects or people appear to fly or simply grow and shrink. Apart from this the technique can be used to add realism to a scene. If an actor is walking on a treadmill with a tracking background projected on the screen behind him, the Zoptic system can make him appear to gradually approach the camera (or alternatively, the camera can be made to appear to recede faster and faster from him).

This is the sort of flexibility that a director would have if he were shooting the scene on location. Because the Zoptic effect can be seen as it happens and is infinitely variable, it enables the creation of very realistic effects as well as those of total fantasy.

Front and back projection Zoptic screen

The Zoptic screen can be mounted inside the framework of the front projection screen so that the two surfaces lie flush with each other and the front projection screen material can be stuck over the Zoptic screen. A desired shape is then cut out with a scalpel and the front projection material peeled off to reveal the Zoptic screen underneath. An image projected onto the Zoptic screen from behind appears as part of the front projected scene. When the Zoptic effect is brought into operation, the back projected object appears to separate from the background and fly through the scene. Again the entire operation is done in one single pass.

This sort of effect is only suitable either for objects with a fixed shape whose outline does not change, or where a mask of a particular shape can be used to give a shape to the subject, e.g. an eye.

The Zoptic screen can also be placed in the windows of a fairly large model of a spaceship or similar structure. The plate of the action within the windows (e.g. pilots) is back projected while the background action (e.g. space) is front projected. The spaceship is lit by polarised lighting and the three elements are filmed

The effect of using the Zoptic screen in conjunction with the front projection screen.

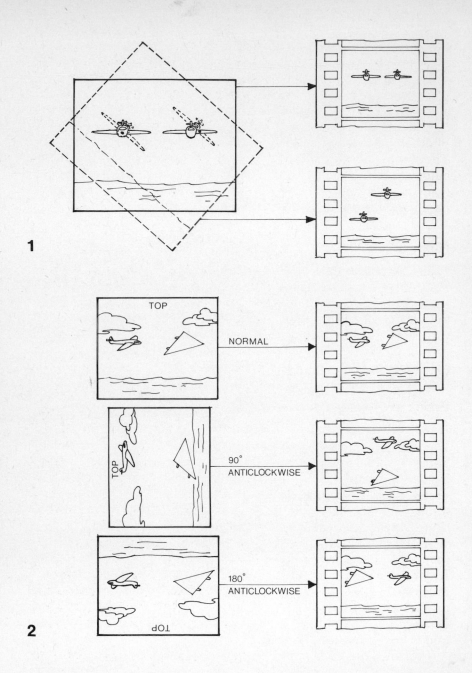

1 By rotating the model aircraft in unison with camera/projector unit the aircraft appear to float relative to each other as though they were not supported on rigid poles.
2 A full 180° anticlockwise rotation creates the illusion that one aircraft has overtaken the other.

176

simultaneously – the spaceship 'flies' towards the camera over a space background and the pilots are clearly visible all the time.

The above example can also be achieved with the use of a large plate of glass – as in the case of matte paintings. The glass is placed at a convenient distance between the camera and the front projection screen. It has to be angled slightly to avoid reflections. A photographic cutout of an aircraft (or similar) is stuck to the glass. The Zoptic screen can be used again in the window areas of the cutout to back project interior action. The Zoptic effect makes the composite appear to move towards the camera and additional panning, tilting and rotation enhances the feeling of realism.

Mixing formats

Using larger formats, both in the original shooting and the preparation of the plates is one way of increasing the definition of the projected image. Projecting 35 mm film and shooting on 16 mm makes it easier to produce a well balanced image, as opposed to projecting and filming on the same format. Projecting a Vistavision format (8 perforation pull down) or 65 mm format and shooting on 35 mm is another approach often used in front projection.

Front projection screen construction

The screen material is available in rolls 2 ft wide and up to 50 yd long. Due to manufacturing problems all the rolls in one particular batch may not be of the same quality. Normally only the best quality is sold to front projection users and the rest goes into industrial usage. Even so, the material should be checked for possible variations in reflectivity and these variations carefully noted down. The 3M company usually offer this service.

A layout of the screen is then prepared, taking great care to match the rolls as well as possible. If there is a 3% fall off in reflectivity between the ends of a section of a roll, as it is applied horizontally from left to right, then on the next strip the roll should be turned around and applied from right to left. In this way the join runs between two sides of the roll which have the same reflective value and is, therefore, less likely to be noticed.

The strips are overlapped at the joins, and provided there is no drastic difference in reflectivity between the strips, these joins are normally invisible. After some time, however, dirt tends to collect at these points and the joins can begin to show up as lines in the photographed picture.

The ideal screen would have no joins in it at all. This, however, is

177

impossible to achieve at present. The next best thing, obviously, is to have as few joins as possible. Generally speaking, this is best achieved by having the joins run horizontally because of the rectangular shape of the motion picture frame – particularly with the anamorphic format. Vertical joins also tend to show up more because they cut across sky areas, whilst horizontal ones merge more easily with the features within the picture. It is light areas, such as the sky, that present the biggest problems in this respect.

The front projection screen material should be applied in a warm atmosphere. It is best to cut the rolls into required lengths and to allow them to adjust to the warm temperature before application. This reduces the risk of buckling and the appearance of bubbles. Apart from looking untidy, the bubbles in the screen are no problem at all initially because they cannot be seen during projection. However, after a certain time the dust accumulated on the screen will be distributed unevenly over the bubbly areas, creating patches of unequal reflectivity. The screen can be washed with detergent and clear water to remove the dust and grime accumulated from the atmosphere. (Naturally this operation has to be done with extreme care.)

Covering large areas

Laying front projection material in long horizontal strips can be a difficult task and other ideas have been tried, such as cutting the material into regular or irregular shapes of varying sizes and applying these individually in a random pattern. This approach makes the actual application a lot easier but the result is not as good as with the horizontal application of long strips.

Soft backing

Under normal circumstances an old back projection canvas screen can be used as the backing for front projection material. Such screens are very useful because they already have rigid frameworks onto which the screen is stretched. The application procedure is also relatively simple.

Hard backing

With the advent of lightweight front projection units designed to pan and tilt across the screen, and with it the need to put poles through the screen to support the subject, a new approach to front projection screen construction had to be devised. Only a

hard backed screen can have a hole put in it for the pole but the application of the screen material to solid surfaces is a lot more difficult than to soft ones. Large solid screens cannot be laid flat on the floor for the application procedure because of the difficulty of erecting them later.

The best method is to divide the screen into manageable sections (the fewer the better). These sections should be fitted to the main fixed frame and adjusted before the application of the screen material, bearing in mind that they will have to be handled and pulled into position only from behind the screen after the front projection material has been applied. The sections are then removed from the framework and covered individually. A special jig can be made up for holding a section at a time to enable both the application and the erection to be carried out more efficiently. In addition, an applicator, comprising of a rubber roller and a support system to hold the roll of material can also be made for this purpose.

The joins between the strips on each section are overlapped in the normal way. However, each section has to have an overlap of its own at the sides where it adjoins the next section. The backing paper should not be removed from this overlap area until the section is in position. The join produced in this way is the same as a normal horizontal join. If vertical joins have to be used it is essential that the same roll of material is always used as a continuation from one section to the next. The overlap join then links two sections of the same roll and is better than a horizontal join.

The front projection material can be applied *in situ* after a screen is erected if an applicator is built for the purpose. This takes the form of a giant gantry which is moved along tracks at the base and top of the screen and running parallel to it. A motor is used to provide a slow constant rate of application. The surface of the hard backed front projection screen has to be prepared carefully before the material is applied to it. It should be lined with paper or canvas to ease the application procedure.

Patching up

It is most important to save a certain amount of spare material from each roll so that a damaged area of the screen can be patched up. For example, if a pole is moved to another position or removed altogether, the hole has to be patched. A piece of front projection material taken from the same roll and placed correctly is not visible during projection. A layout of the screen should always be prepared before application and used for reference later.

179

Curved screens

Panning and tilting the front projection unit is possible because the reflectivity of the screen remains reasonably constant over a wide range of angles. The only serious problems, therefore, with flat screens are keystoning and focus fall off and then only at considerably wide angles.

Keystoning is a problem insofar as a wider screen has to be used to ensure that part of the picture farthest from the unit does not disappear off screen. Keystoning itself is not noticeable in the projected background because the distortion is cancelled out by the camera lens, which is subject to the same distortion.

Focus fall off on the side of the frame farthest from the front projection unit can be a more serious problem when the depth of field of either or both lenses is very shallow. Giving the screen curvature helps to reduce both keystoning and focus problems.

180

Glossary

Academy aperture (10) The opening in a 35mm camera or projector gate defined by the United States Academy of Motion Pictures Arts and Sciences. Smaller than the maximum frame area and shifted to one side it leaves room for an optical sound track.

Angle of incidence (114) Angle formed by the light rays from a source and the plane of the subject being photographed.

Ambient light (146) A general light level produced by scatter and diffusion in areas which are not lit directly.

Anamorphic lens (178) Normally an image formed by a (spherical) lens preserves the same proportions between the horizontal and vertical parts of the image as the subject. However, an anamorphic lens produces squeeze of the image in one plane only, ie the horizontal, while the other plane is unaffected.

Bipack (56) The use of two strips of film in contact with each other (usually emulsion to emulsion) in a camera or projector gate.

Bipack magazine (71) A four chamber magazine which enables two rolls of film to be fed to and taken up from a camera or projector.

Beamsplitter (98) Semi-transparent (two-way mirror); a rightangle prism.

Counter matte (91) A matte which is the opposite shape to another matte; it is one of a matching pair.

Cam (108) (See **Follow Focus Cam**).

Contact printing (116) A method of printing where the raw stock is held in contact (emulsion to emulsion) with the film bearing the negative or positive image to be copied.

Crabbing (165) Tracking the camera sideways.

CRI (Colour Reversal Internegative) (50) A type of duplicating film stock used in the production of duplicate negatives by reversal

Cels (102) Transparent plastic sheets used as a base onto which animation artwork is traced and painted.

Colour temperature (42) Measure of the colour of a light source by relating it to theoretically perfect (black body) source of radiant energy. The colour changes from reddish to bluish as the temperature, measured in kelvins (K) rises.

Compound move (104) A move requiring two or more movements to be executed simultaneously.

Depth of field Area of acceptably sharp focus in front of and beyond the plane of primary focus. It is determined by the focal length of the lens, f stop and the position of the primary focus.

Dichroic filter (98) A filter which separates the infra-red radiation from the light spectrum.

Dioptre lens (36) A single lens element added to the front of the shooting lens to alter the focusing characteristics of the lens. Can be either positive or negative. (One dioptre is equivalent to a focal length of 1000mm).

Diptest (27) Quick processing of a short length of film using the same facilities as for processing stills.

Dissolve (25) An optical transition; as the outgoing scene gradually disappears it is replaced by the incoming one.

Drop shadow (85) A black shadow, corresponding to the outlines of lettering, obscuring part of the negative. When the lettering is added it can be tinted any colour. A larger shadow shifted slightly to one side of the lettering remains visible and can improve legibility on difficult backgrounds.

Exponential zoom (106) The image size is increased (or decreased) at a constant rate throughout the full length of the track (zoom).

Fade (in/out) (25) A progressive opening or closing of a variable shutter on the camera will cause the scene being photographed to appear from the black (fade in) or disappear into black (fade out).

Fairing (104) Speeding up and slowing out at the start and the end of a moving shot to soften the transition from and to static holds.

Female matte (91) A matte (mask) which is clear in the area of the subject and opaque in the surrounding areas.

Focal length The distance between the centre of a lens and the point at which the image of a distant object comes into critical focus. In practical terms this also relates to the angle of view or angle of acceptance of a lens; ie a lens of longer focal length has a narrower angle of view than a lens of shorter focal length when used for a particular film format.

Focus pull (81) Altering the position of any primary focus of the lens, to maintain focus or to make the scene go out of focus during a take.

Follow focus cam (108) A cam cut to respond to the focusing curve as the camera moves closer or farther from it.

Foot candle (116) A unit for measuring the intensity of light. It represents the luminous intensity of one standard candle on a surface a foot square placed at a distance of one foot from the candle.

Gate (27) Part of a camera or projector mechanism which holds the film during exposure or projection.

Graticule (112) The frame outline engraved on the ground glass in the camera viewfinder. Can include any suitable framing or lining up information.

Interpositive (91) A film bearing a positive image which is used in the production of a composite negative or a straight duplicate negative.

Iris A variable aperture controlling the amount of light passing through the lens; a scale on the outside of the lens is calibrated in f stops.

Kelvin (42) The unit of temperature measurement used for colour temperature.

Key light The principle light used for the illumination of a subject.

Keystoning (144) Distortions of the projected image when the projection screen is not perpendicular to the projection lens axis.

Matte (20) Any opaque object which prevents the light reaching the film in a specific area of the frame, it can be placed at the artwork level, in front of the lens, behind the lens or in the camera (or projector) gate. (See also **Travelling matte**.)

Mix (See **Dissolve**).
Male matte (91) A matte (mask) which is opaque in the area of the subject and clear in the surrounding areas.

Negative perforations (50) (See **Perforations**).
Neutral density filters (114) Filters designed to cut down the transmission of visible light without affecting the colour.
Nodal pan (156) When the pan axis is coincidental with the nodal point of the camera lens, there is no noticeable change in perspective during the pan.

Opal glass (56) A milky plastic often used as a diffuser.
Optical sound track A narrow band which carries the sound record, optically printed.

Panchromatic stock (55) Black-and-white film stock sensitive to the full range of colours in the visible spectrum; often used to produce black and white separation positives from colour negatives.
Pegbar (91) A metal strip with three pins used for registering animation artwork; normally the middle pin is round and the other two flat. It may be fixed or travelling, when it is moved by a worm-screw drive to pan the artwork attached to it. A series of round and flat pegs can be screwed into specific positions along the pegbar to which the artwork is registered.
Perforations (50) Accurately punched holes running along the edges of film stock which are used for transportation and registration. Negative camera stock is punched with negative perforations and positive stock with positive perforations, although some positive stocks are available with negative perforations.

Rack-over reflex viewfinder (110) Camera viewfinder which allows a scene to be viewed through the taking lens only for lining up when the camera body is moved to one side.
Raw stock (19) Unexposed film.
Rotoscope lamp (112) Light source used in rotoscoping.

Self-matting (91) A self-matting image does not require a counter-matte; the areas around the image are opaque.
Step printing (57) (116) Copying of a positive or negative image from a processed film onto raw stock by means of a machine employing an intermittent movement. This operation can be done either 'in contact' or 'optically'.
Synchronisation (26) Matching the speeds of two or more motors used to drive film cameras and process projectors or sound recording equipment.

184

Sync mark A specific frame which acts as a zero point for the start of a shot; it also represents the synchronisation point between a piece of film and a soundtrack or other piece of film with which it may eventually be combined.

Travelling matte (91) Mattes prepared on high contrast motion picture stock and used in the camera in contact with the raw stock. They change from frame to frame as dictated by the scene being shot.

T stop (152) This is a more accurate way of marking the lens iris as it refers to the measurements of transmission of the specific lens and is not merely based on geometric calculations as the f stop is.

Undercranking (14) To run the camera at a speed which is slower than the projection speed.

Vistavision (10) This is a format using 35mm film which runs horizontally instead of vertically through the camera; the image occupies an area of eight perforations instead of standard four.

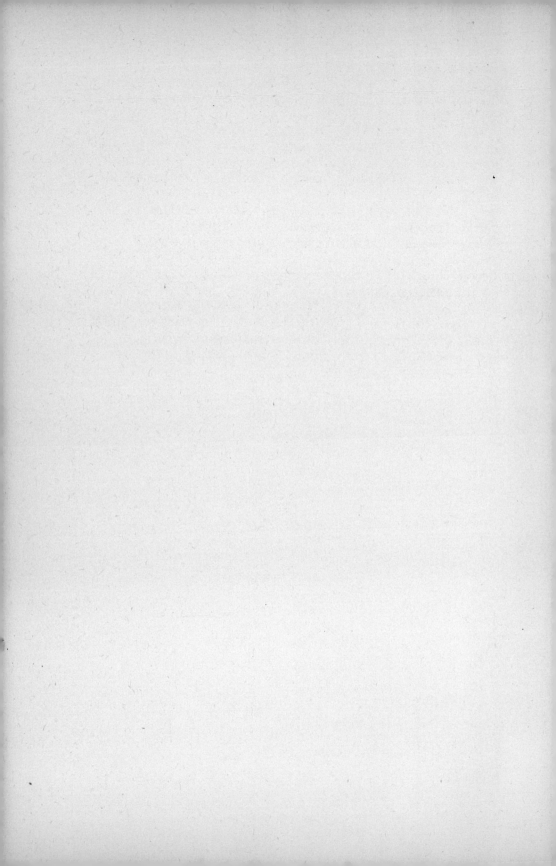